MOSAIC AND TESSELLATED PATTERNS

HOW TO CREATE THEM
WITH 32 PLATES TO COLOR

JOHN WILLSON

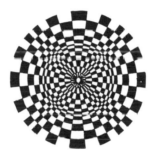

DOVER PUBLICATIONS, INC.
NEW YORK

For Christopher, Katharine and Jonathan.

Plates follow page 14
Descriptive list of plates appears on page 30

Published in Canada by General Publishing Company, Ltd., 30 Lesmill Road, Don Mills, Toronto, Ontario.

Published in the United Kingdom by Constable and Company, Ltd., 10 Orange Street, London WC2H 7EG.

Mosaic and Tessellated Patterns: How to Create Them/With 32 Plates to Color is a new work, first published by Dover Publications, Inc., in 1983.

DOVER *Pictorial Archive* SERIES

Manufactured in the United States of America
Dover Publications, Inc., 31 East 2nd Street, Mineola, N.Y. 11501

Library of Congress Cataloging in Publication Data

Willson, John Scott.
 Mosaic and tessellated patterns.

 (Dover pictorial archive series)
 1. Decoration and ornament. 2. Optical art.
3. Tessellations (Mathematics). I. Title. II. Series.
NK1570.W5 1983 745.4 82-9557
ISBN 0-486-24379-6 (pbk.)

What Is a Tessellation?

A Roman mosaic consisted of many small stones which were laid edge to edge to cover a surface, such as a wall or a floor. These tiles were called *tesserae,* and the term *tessellation* is now used for any arrangement of shapes that completely covers a surface. This technique of space-filling can be seen in paved or parquet flooring, in ceramic tiling and in stained-glass windows. Tessellations even occur naturally on some crystal surfaces and in many cellular structures such as honeycombs. Tessellation is a form of design which has been used for thousands of years. Patterns found in a Roman villa in Greece, an Islamic mosque in Iran and the Alhambra palace in Spain are shown in Figures 1, 2 and 3 respectively. Similar designs occur in many other countries which have been influenced by Greek, Roman, Byzantine or Arabic culture.

These patterns have inspired artists and designers throughout the centuries. In the last few decades, they have found a new lease on life through the work of Victor Vasarely, Bridget Riley, Maurits Escher, Ensor Holiday and many others.

In this book the basic principles of tessellation will be studied and various methods of creating new patterns will be explained. Some curious effects of shading will be analyzed, and in the center pages of the book there are many designs to explore, modify and color.

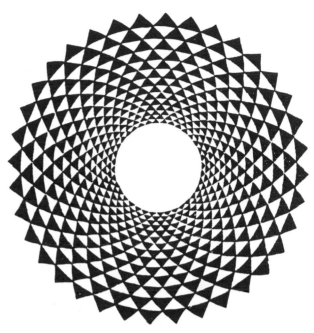

Fig. 1

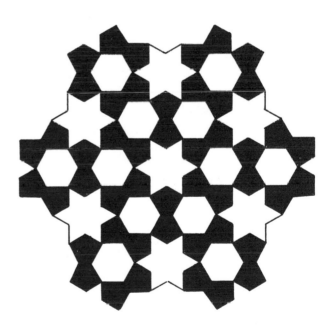

Fig. 2

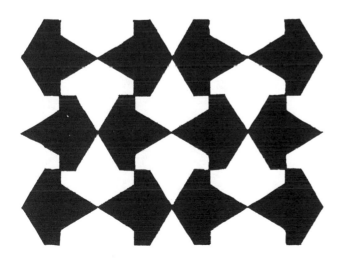

Fig. 3

1

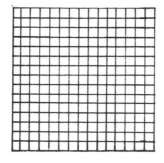

Fig. 4

Effects of Color

Many tessellations take on new appearances or produce interesting optical effects when shaded or colored. The effects are often most noticeable when the designs are viewed from a distance or in subdued lighting or with one's eyes partially closed or screwed up. Hence the square pattern in Figure 4 gives an overall horizontal-vertical impression, but when alternate squares are shaded (Figure 5) the pattern seems to be crossed by diagonal lines. The effect is more obvious in Figure 6, where the pattern of rectangles involves only straight lines but on shading (7) develops a curving, three-dimensional appearance.

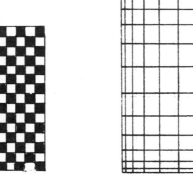

Fig. 5

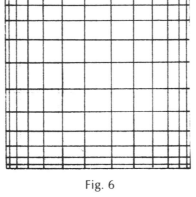

Fig. 6

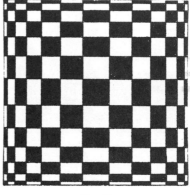

Fig. 7

This effect in some ways resembles the moiré effect in which bands of light and shade are produced when two grids or sets of lines overlap. The relationship can be seen in this tessellation of various shapes produced by overlapping two sets of lines radiating from two points (8). On coloring in alternate areas we see bands sweeping over the pattern in a series of horseshoe shapes. A similar set of curves is seen if the original grid is drawn using much thicker lines so as to produce a moiré effect (9).

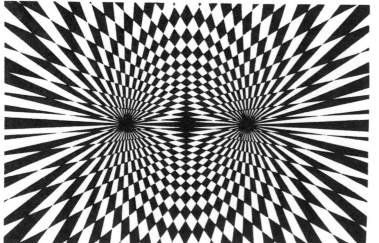

Fig. 8

Fig. 9

The tessellations on the opposite page are based on very regular grids in which the spacing between the lines is either constant or varies steadily. As a result, one color does not predominate in any area of the overall pattern. If the spacing between the grid lines fluctuates greatly, however (10), then the shaded pattern may contain regions in which the tiles of one color are much larger than the tiles of the other color. This produces an impression of areas of light and shade which have no definite boundaries but simply merge into each other (11).

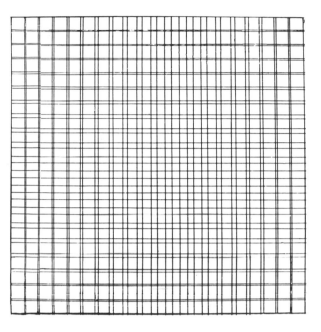

Fig. 10

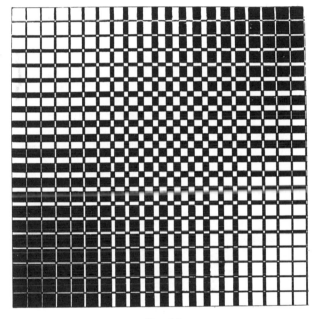

Fig. 11

An additional effect which can occur in some patterns is the temporary association of several adjacent areas such that a larger shape is perceived. In Figure 13 the basic tessellation of small triangles gives an impression of much larger triangles which overlap each other. The brain oscillates between perceiving large black areas and large white areas, "pointing" in opposite directions. An alternative impression is that of a three-dimensional surface such as that of a water biscuit in which highlights and shadows are produced by strong side illumination.

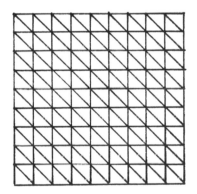

Fig. 12

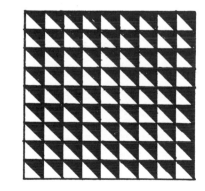

Fig. 13

3

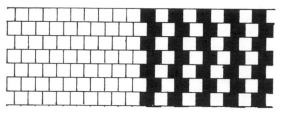

Fig. 14

The tessellations on the previous pages required only two different colors to shade in the tiles so that areas of the same color did not touch along a common edge. However if squares are arranged so as to produce a brick-wall pattern (14), then, on shading with black and white, only some areas of the same color are touching. As a side effect we produce an illusion in which the squares seem to be distorted into wedge shapes. In this tessellation three colors are required if all the tiles of the same color are to be completely separate (15).

Some three-color designs, such as the bricks (15) and the honeycomb (16), do not take on a markedly different character on shading, as the areas of similar color are so far apart that the brain does not link them into a single composite unit. However there are some which do change in appearance. The unshaded pattern in Figure 17 gives rise to several different impressions which seem to fluctuate in intensity as we look at them. By shading we can enhance the impression of stars surrounded by large overlapping hexagons (18), or, alternatively, we can reinforce the three-dimensional cube appearance (19).

This flexibility of varying the effect by modifying the shading cannot usually be applied to two-color designs. With these, in most cases, interchanging the black and white does not significantly alter the appearance.

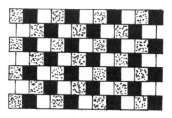
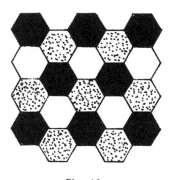

Fig. 15

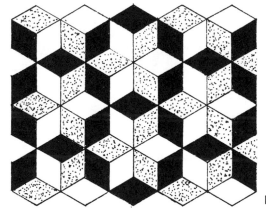

Fig. 16

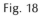
Fig. 18

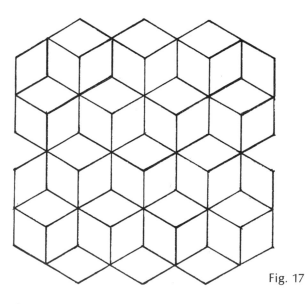

Fig. 17

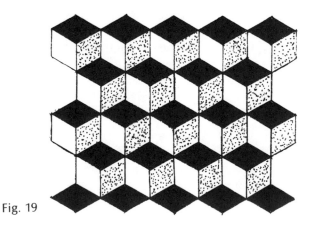

Fig. 19

It is obvious that any pattern in which three edges or lines meet at a point will require at least three colors to shade in the three areas which meet at that point. If a pattern *only* involves intersections of four, six, eight or ten lines, then two colors will suffice (20). If a pattern contains any points at which an odd number of lines meet, then it will require at least three different colors to shade it satisfactorily (21). Regular tessellations which require four colors are not common and most of these are of a complex nature. Probably the simplest four-color design is the double tessellation of triangles and dodecagons (22).

It has been shown using a theory of topology (a branch of mathematics) that there is no tessellation which requires more than four colors to ensure that adjacent areas are of different colors.

Some of the designs in the book have been left unshaded; by coloring the tiles carefully some interesting effects may be produced.

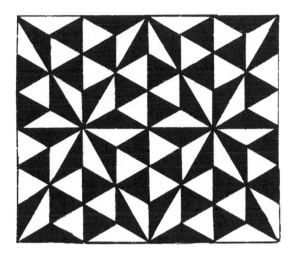

Fig. 20

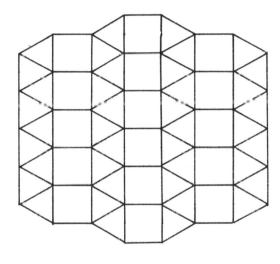

Fig. 21

Fig. 22

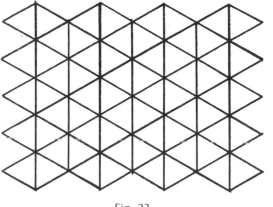

Fig. 23

Types of Tessellation

Tessellations can be categorized according to the number of different tiles involved and by the regularity, symmetry and periodicity of the pattern.

In single tessellations all tiles are of the same shape (e.g., Figure 23 and Plates 1 and 3).

In double tessellations the two tiles may have different shapes (e.g., Figure 24 and Plates 14–17) or they may be different sizes of the same shape (e.g., Figure 25).

In triple tessellations the three tiles may have three different shapes (e.g., Plates 4, 6 and 8), they may be two sizes of one shape plus another shape (e.g., Figure 26) or they may be three sizes of one shape (e.g., Figure 27).

In multiple tessellations, numerous tiles of different sizes and/or shapes are used (e.g., Figure 1 and Plates 21–32).

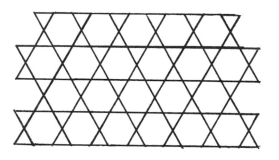

Fig. 24

Fig. 26

Fig. 25

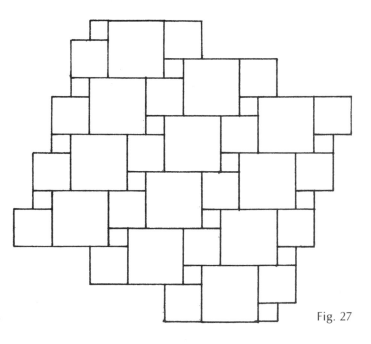

Fig. 27

Symmetry and Periodicity

Many tessellations show rotational symmetry or mirror symmetry. In the former case the pattern is repeated several times on rotating the design about some point called the center of rotation. A pattern of squares has two different fourfold centers of rotation (28, 29). The single tessellations of regular hexagons or triangles have threefold and sixfold centers of rotation (30, 31). Most of the patterns (128–160) based on regular division of a circle have a 36-, 18-, or ninefold center of rotation.

Mirror symmetry is the property by which one-half of a pattern can be regarded as the mirror image of the other half. An imaginary line can be drawn across the pattern and the complete design is produced if the tiles on one side of this line are also seen reflected in a mirror placed on the line. In the square pattern four lines of symmetry intersect at the center of rotation. In the patterns formed by hexagons and triangles three lines of mirror symmetry intersect at the threefold centers and six lines cross at the sixfold centers (32). This direct relationship is not necessarily found in all patterns but it can be shown that if two lines of mirror symmetry intersect then that point must be at least a twofold center of rotation. The tessellation of fylfot crosses (33) shows that it is possible to possess two fourfold centers of rotation in the absence of lines of mirror symmetry.

A tessellation is described as being periodic if a tracing of the pattern can be moved to other positions on the design and still match perfectly in all places (e.g., Figure 33). This process is known as translation. Some designs which possess lines of symmetry or centers of rotation are also periodic (e.g., Figures 15–25), but some symmetrical patterns are nonperiodic, e.g., the "circular" patterns. It is possible to create an infinite number of periodic patterns which possess neither lines nor centers of symmetry (e.g., Figure 34), and of course any random division of a surface will produce a nonperiodic asymmetrical tessellation. It is found that any nonperiodic arrangement of any single shape can always be reordered into a periodic pattern.

Fig. 28

Fig. 29

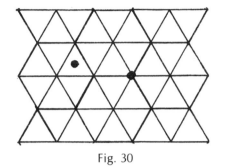

Fig. 30

Fig. 31

Fig. 32

Fig. 34

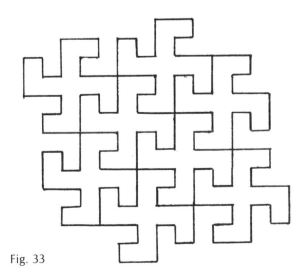

Fig. 33

Fig. 35

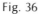

Fig. 36

Fig. 37

Fig. 38

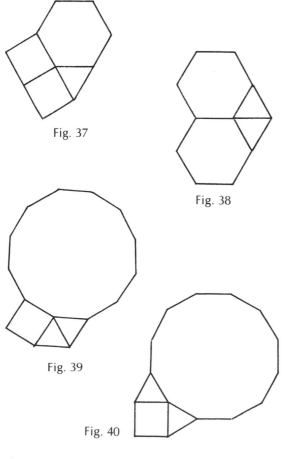

Fig. 39

Fig. 40

Regularity

A regular polygon is a shape in which all angles are equal and all sides are of the same length. Only three of these polygons—triangles, squares and hexagons—will tessellate on their own and these are known as the regular tessellations (23, 4 and 16). The reason for this limitation becomes clear if we consider the interior angles of the simplest regular polygons.

Triangle	(3 sides)	angle = 60°
Square	(4 sides)	angle = 90°
Pentagon	(5 sides)	angle = 108°
Hexagon	(6 sides)	angle = 120°
Heptagon	(7 sides)	angle = 128.6°
Octagon	(8 sides)	angle = 135°
Nonagon	(9 sides)	angle = 140°
Decagon	(10 sides)	angle = 144°
Hendecagon	(11 sides)	angle = 147.3°
Dodecagon	(12 sides)	angle = 150°

To completely surround a point the sum of the angles meeting at that point must be 360°, and so the only possibilities are six triangles or four squares or three hexagons. By using more than one type of regular polygon it is possible to draw eight semiregular tessellations in which every meeting point has an *identical* arrangement of tiles. These eight arrangements with angles totaling 360° are:

Three triangles and two squares arranged as in Plate 2
Three triangles and two squares (as in Figure 21)
Four triangles and one hexagon (Figure 35)
Two triangles and two hexagons (as in Figure 24)
One triangle, two squares and one hexagon (as in Plate 4)
One triangle and two dodecagons (Figure 22)
One square, one hexagon and one dodecagon (Plate 10)
One square and two octagons (Figure 36)

Consideration of the angles in the list above suggests that five other arrangements may satisfy the required conditions:

Two pentagons and one decagon (Plate 13)
One triangle, two squares and one hexagon (as in Figure 37)
Two triangles and two hexagons (as in Figure 38)
Two triangles, one square and one dodecagon (as in Figure 39)
Two triangles, one square and one dodecagon (as in Figure 40)

In addition to these there are five other arrangements of regular polygons around a point. They involve polygons with 42, 24, 20, 18 and 15 sides. Although all ten arrangements satisfy the 360° condition, it is found to be impossible to extend the patterns into semiregular tessellations in which every meeting point is *identical*. However, these arrangements are worth noting, as they can form the basis of many periodic or symmetrical tessellations (e.g., Plates 5–9).

Development of Other Tessellations from Basic Patterns

(1) A reciprocal tessellation can be formed by joining the center of each tile in any pattern to the centers of all the tiles which surround it. A single tessellation of triangles is the reciprocal of the simple hexagon pattern, and vice versa (41). Squares are self-reciprocating (42). The number of different shapes created corresponds exactly to the number of different intersections in the original design and the symmetry of the pattern is often retained. Hence all the semiregular patterns produce single reciprocal tessellations (e.g., Plates 1 and 3).

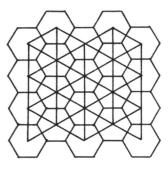

Fig. 41

Fig. 42

(2) Expansion of a tessellation involves separating all the tiles in some basic pattern and then filling in the intervening spaces with other tiles. Expansion of a triangular grid gives Figure 43, which leads to the semiregular grid on Plate 4.
Expansion of a simple hexagon pattern to give Figures 44 and 45 can lead to the semiregular grid (35) and the varied designs of Plates 4, 8 and 11.

Fig. 43

Fig. 44

Fig. 45

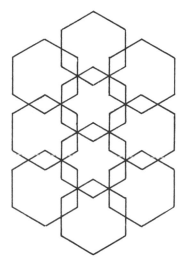

Fig. 46

(3) Overlapping the sides of polygons rather than placing them edge to edge is the reverse of expansion. Hexagons, octagons and dodecagons can be overlapped in many ways, one example of each being shown in Figures 46, 47 and 48. Plate 4 is another variation of dodecagons overlapping.

(4) The superimposition or overlaying of two grids which have similar degrees of symmetry can produce complex but symmetrical tessellations involving much smaller tiles; for example, the patterns in Figures 49 and 50 are formed by superimposition of triangle grids and hexagon grids respectively.

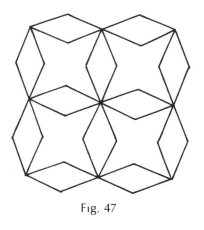

Fig. 47

Fig. 48

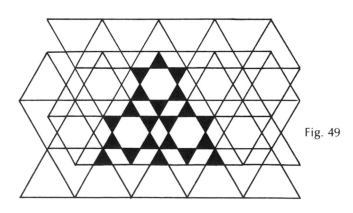

Fig. 49

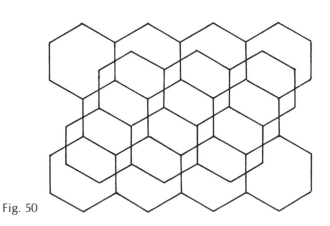

Fig. 50

(5) Combination of two or more adjacent areas in a pattern produces a tessellation of larger tiles which may have very complex shapes.

Combination of two triangles gives diamonds, two diamonds form a chevron (53) and three diamonds can give a honeycomb (54) or half-star pattern (55).

The pattern of stars and diamonds in Figure 46 is formed from selective grouping of six diamonds.

Combination of hexagons gives various shapes, such as those in Figures 56–59, all of which will tessellate on their own.

Fig. 51

Fig. 52

(6) Division is the reverse of combination but is a much more flexible process.

A sixfold division of each tile in a hexagon pattern can produce not only the simple triangle grid but also many other single tessellations using the shapes in Figure 60.

Twofold division of hexagons gives the tesserae in Figure 61, and threefold division gives those in Figure 62. All of these tiles will tessellate singly.

A dodecagon can be split up into six triangles, six squares and a hexagon, or into twelve triangles and six squares (Plates 11 and 12).

Fig. 53

Fig. 54

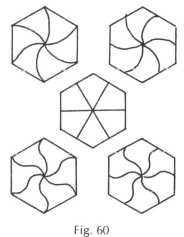

Fig. 55

Fig. 56

Fig. 57

Fig. 58

Fig. 59

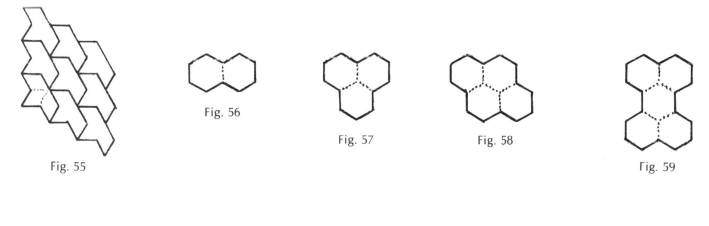

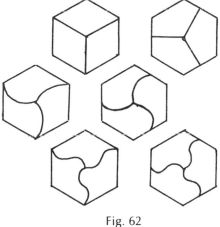

Fig. 60

Fig. 61

Fig. 62

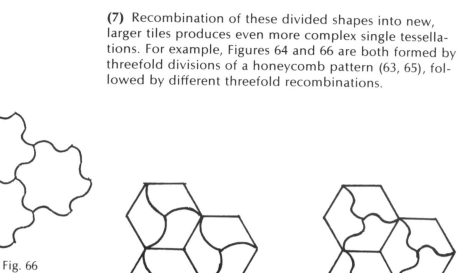

(7) Recombination of these divided shapes into new, larger tiles produces even more complex single tessellations. For example, Figures 64 and 66 are both formed by threefold divisions of a honeycomb pattern (63, 65), followed by different threefold recombinations.

Fig. 64

Fig. 66

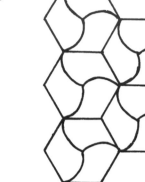

Fig. 63

Fig. 65

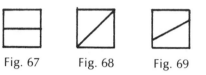

Fig. 67 Fig. 68 Fig. 69

Fig. 70 Fig. 71

Fig. 72 Fig. 73 Fig. 74

Fig. 75 Fig. 76

This process of division and recombination can be applied to any single tessellation to create new single tessellations. Squares can be divided into two pieces, as in Figures 67–71, or into four shapes, as in Figures 72–76. These halves and quarters will clearly tessellate as in Figures 77, 78 and 79, and by recombination they produce numerous other tiling shapes, such as those in the shaded areas.

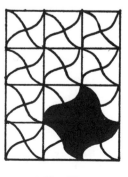
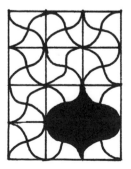
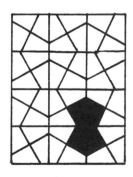

Fig. 77 Fig. 78 Fig. 79

(8) Some of the patterns obtained by these processes can be further developed by rearrangement of the shapes. The kite-shaped tiles formed by a sixfold division of a honeycomb (80) can be rearranged to give Figure 81, and after threefold or fourfold recombination give the single tessellations in Figures 82 and 83.

Trapezium-shaped tiles formed by twofold division of a honeycomb (84) can be rearranged into the tessellations in Figures 85, 86 and 87. In Figure 86 the tiles are rearranged to form a larger trapezium. Because of this replicating property they are known as rep-tiles. Combination of the two adjacent areas in Figure 87 gives another rep-tile pattern known as the sphinx (88).

Fig. 80

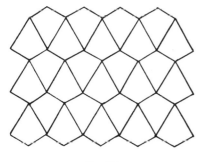

Fig. 81

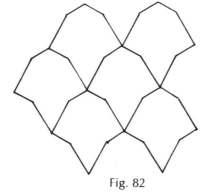

Fig. 82

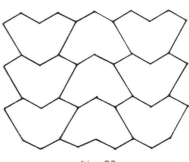

Fig. 83

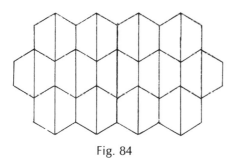

Fig. 84

Fig. 85

Fig. 86

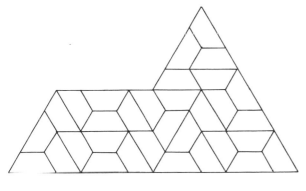

Fig. 87

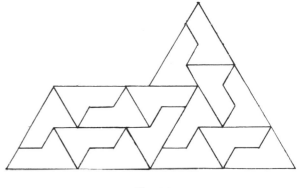

Fig. 88

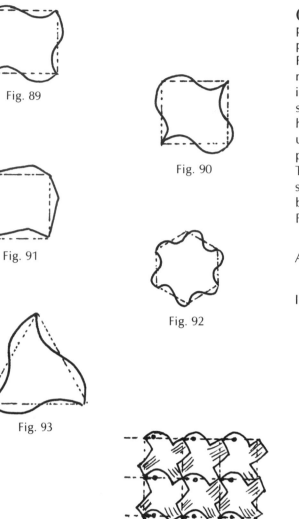

Fig. 89

Fig. 90

Fig. 91

Fig. 92

Fig. 93

(9) Modification of the sides of tesserae can be used to produce exceedingly complex shapes which still tessellate perfectly.

Figures 89–92 show a variety of tiles which are formed by modifying opposite sides of a square or hexagon in an identical way. These shapes produce the tessellations shown in Figures 77, 78, 82 and 66. A triangle does not have pairs of opposite sides but the process can still be used if each line is modified symmetrically about its midpoint (93).

This method can be used to create an infinite number of single periodic tessellations in which each tile is identical but which may have no symmetry at all. For example, in Figure 94 all horizontal lines are modified to

All vertical lines are modified to

In Figure 95

/ is changed to

— is changed to

\ is changed to

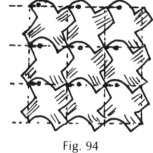

Fig. 94

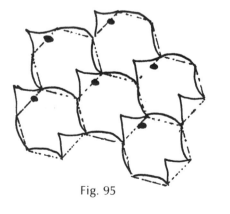

Fig. 95

A further type of modification can be performed on square patterns to produce interlocking shapes. All four sides are modified in a similar manner but opposite faces are mirror images of each other. For example, see Figures 96 and 97.

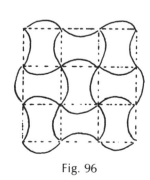

Fig. 96

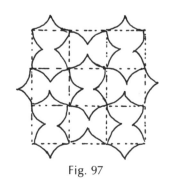

Fig. 97

(The text pages continue after the coloring section.)

Plate 1

Plate 2

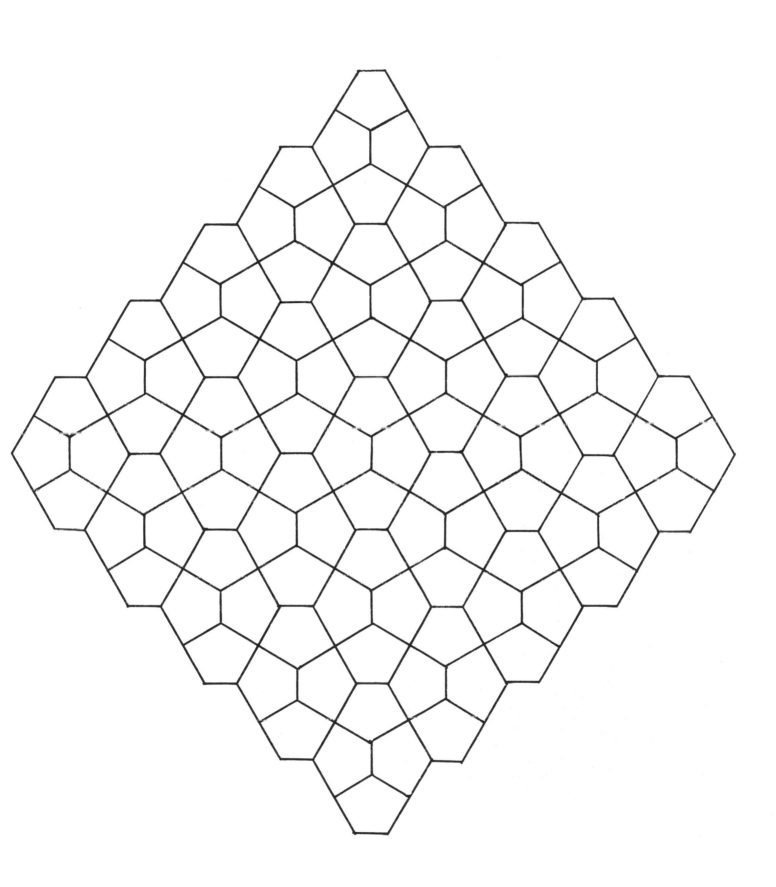

Plate 3

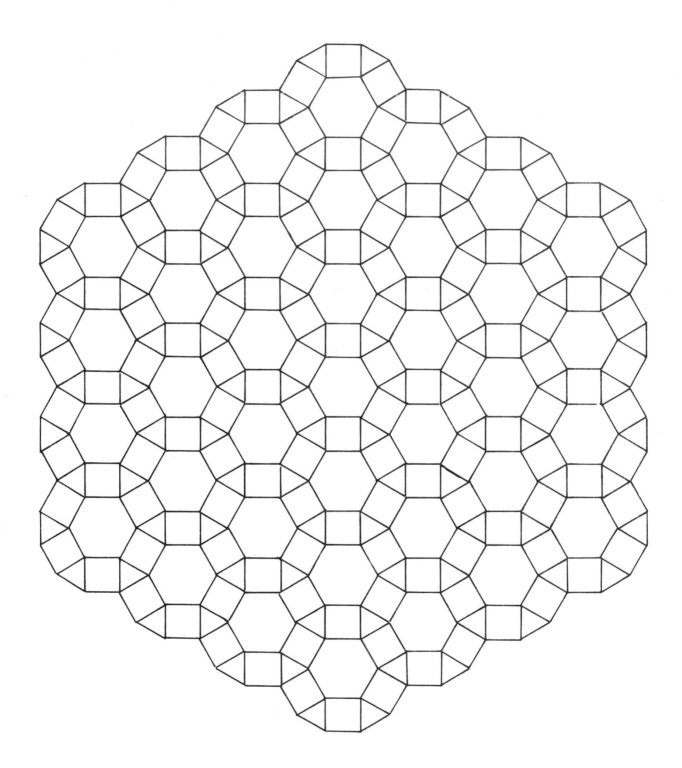

Plate 4

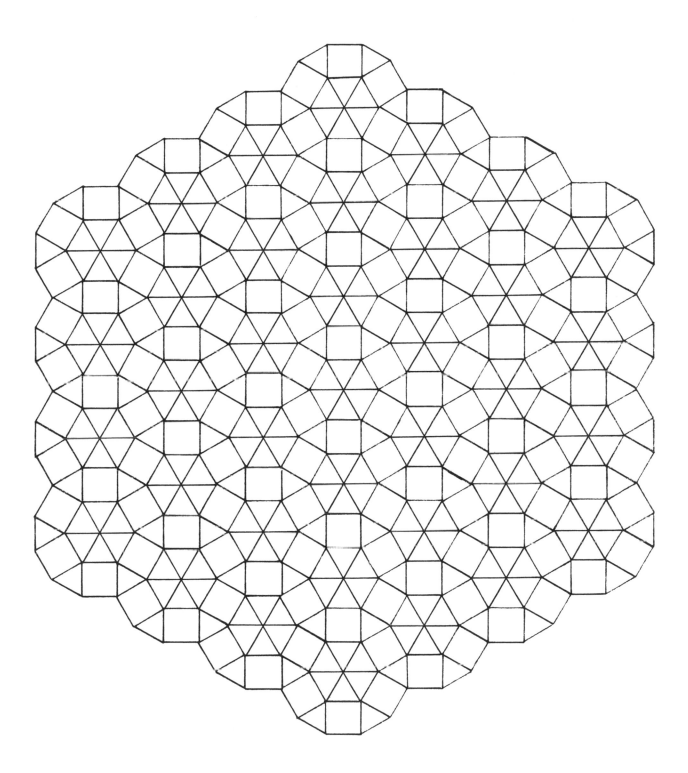

Plate 5

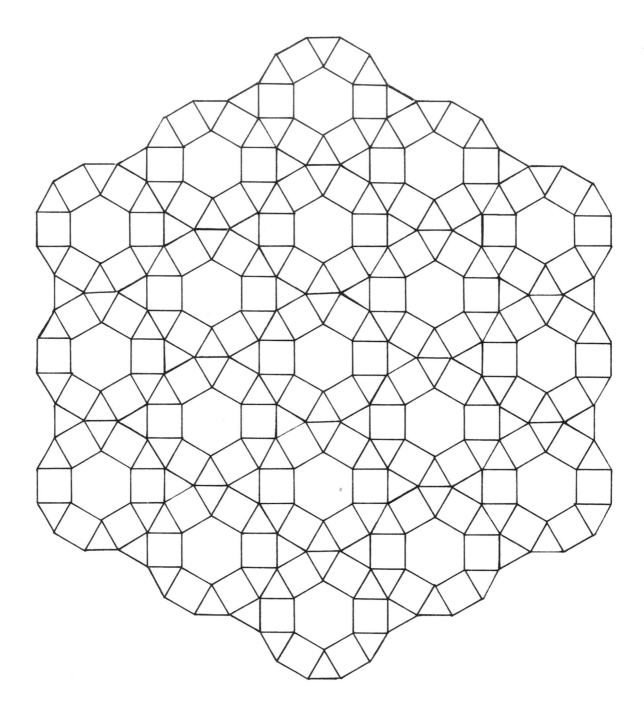

Plate 6

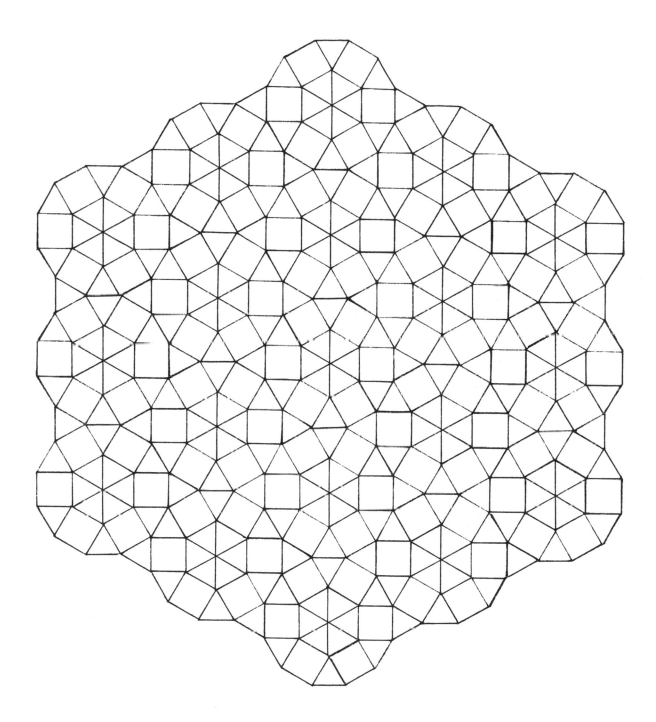

Plate 7

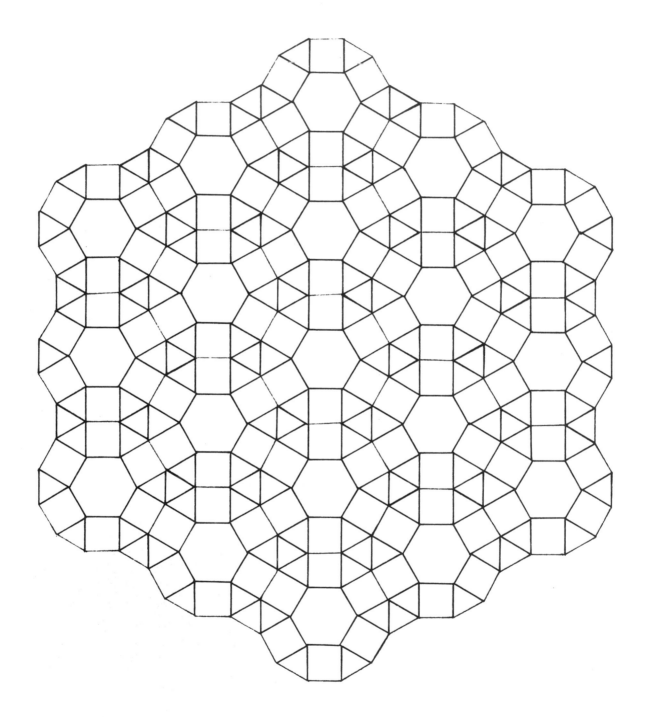

Plate 8

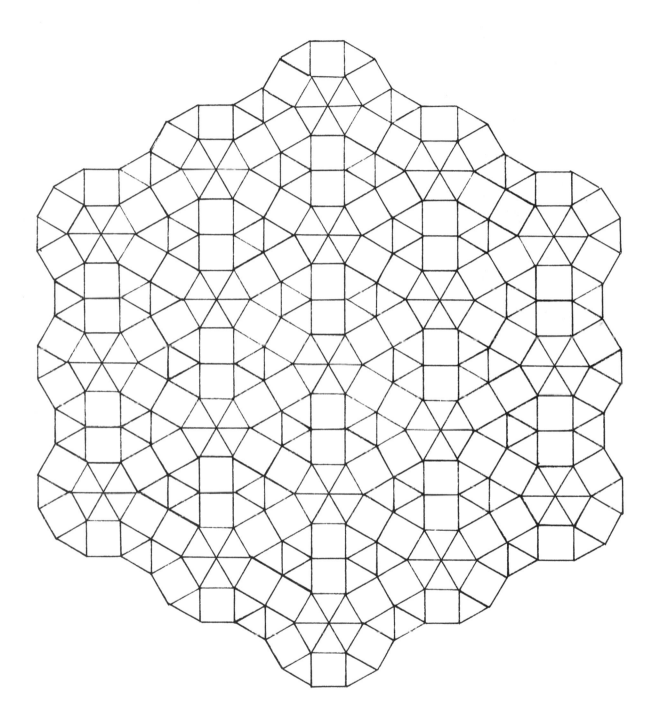

Plate 9

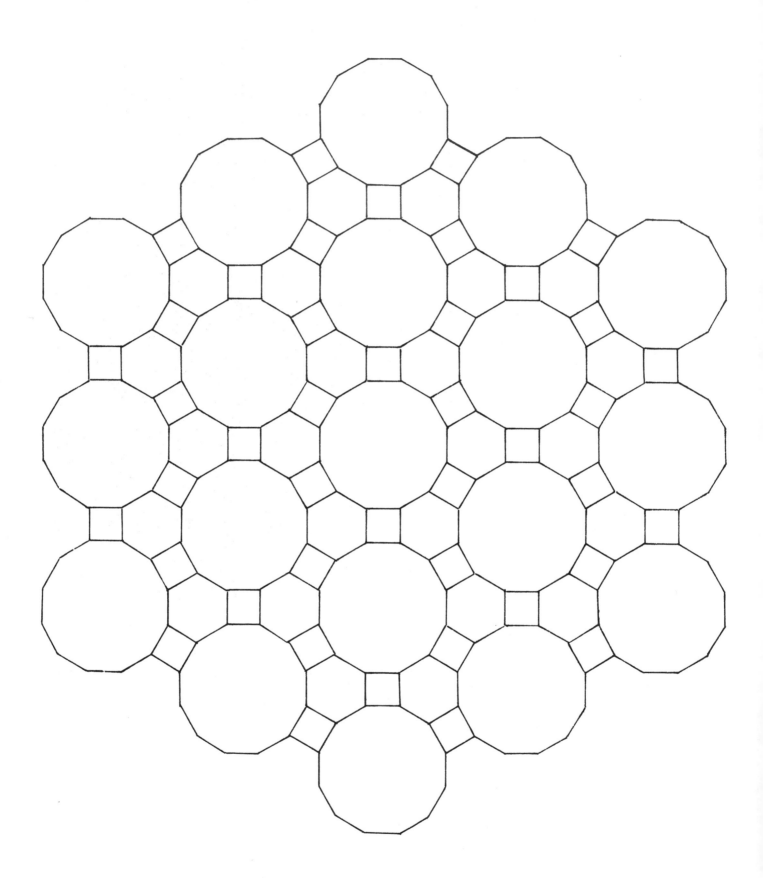

Plate 10

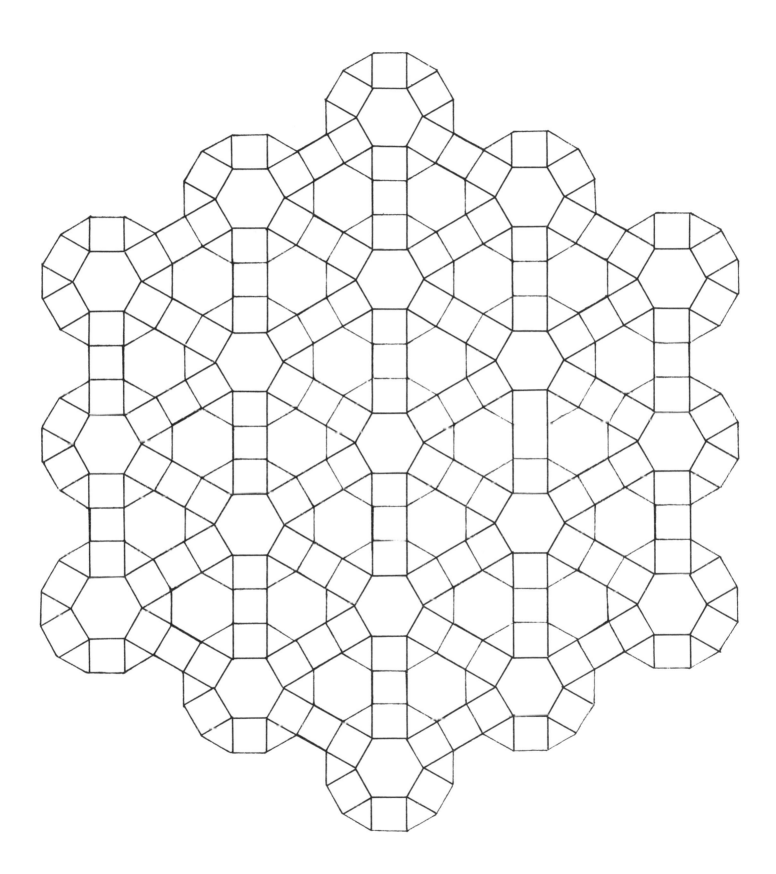

Plate 11

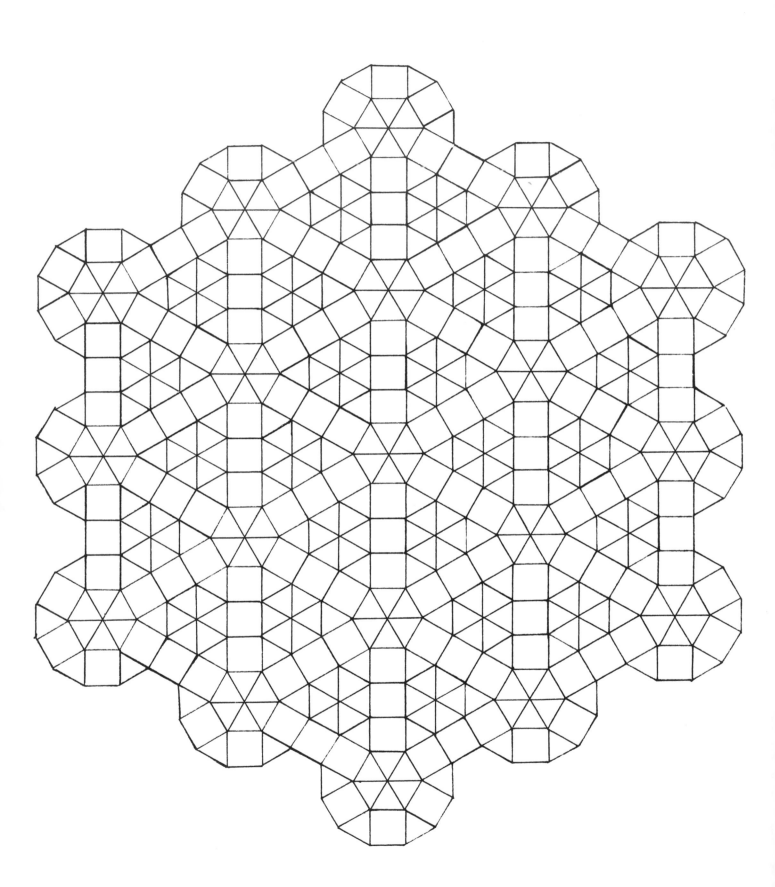

Plate 12

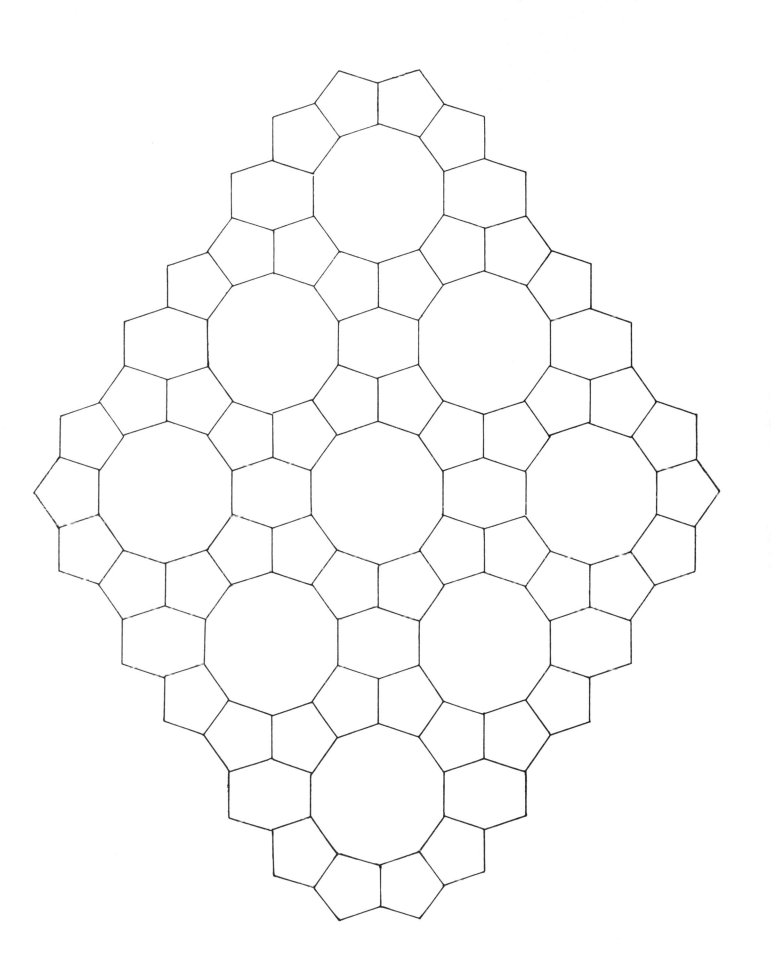

Plate 13

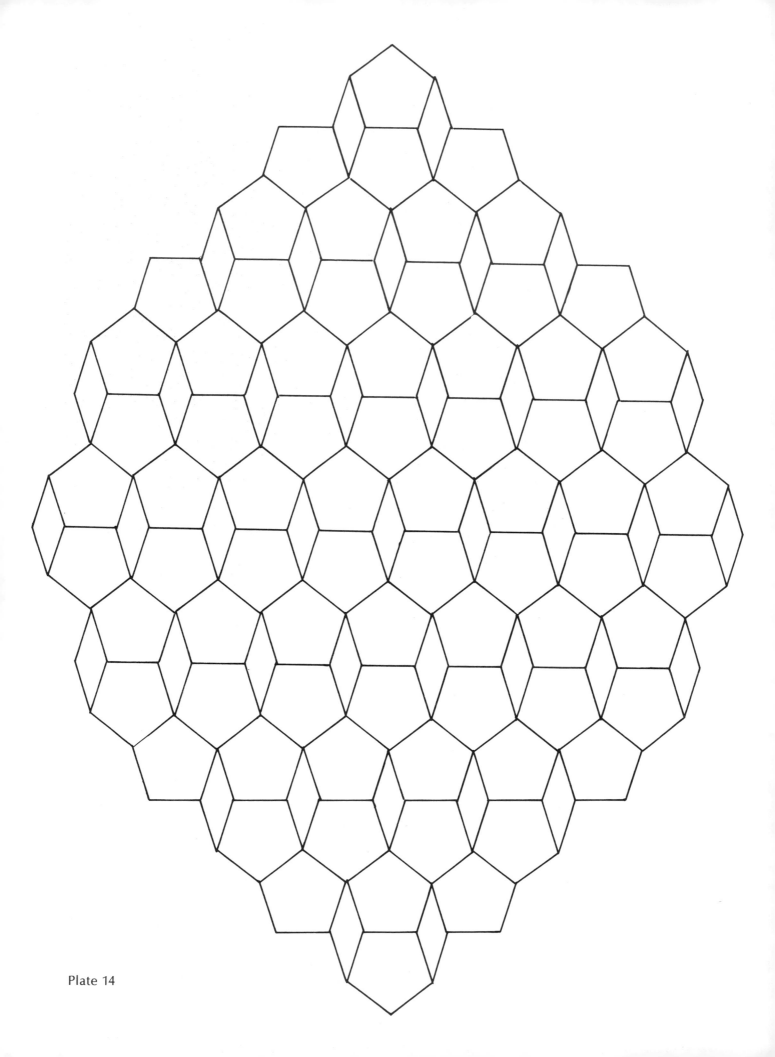

Plate 14

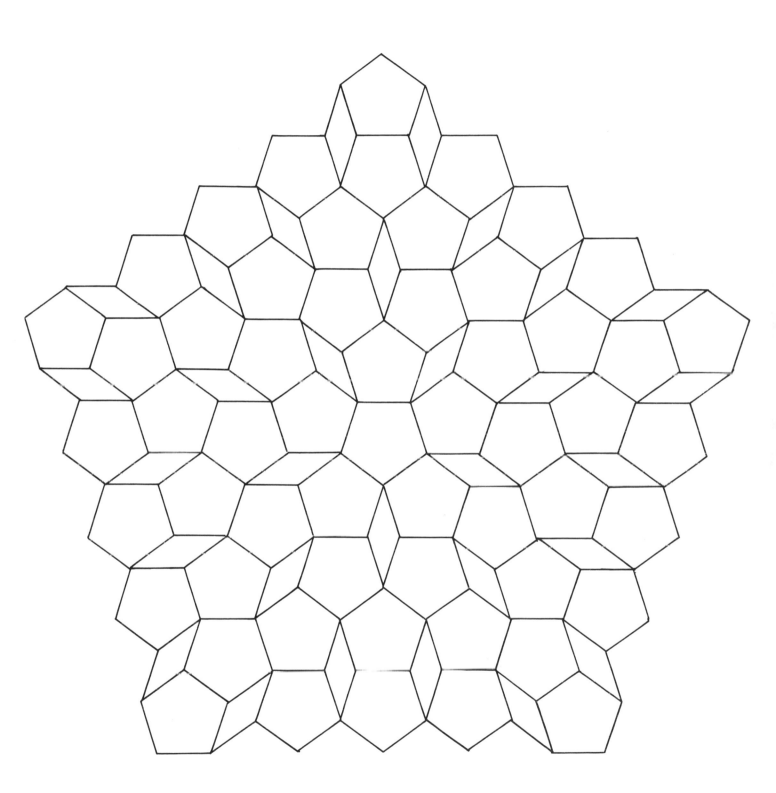

Plate 15

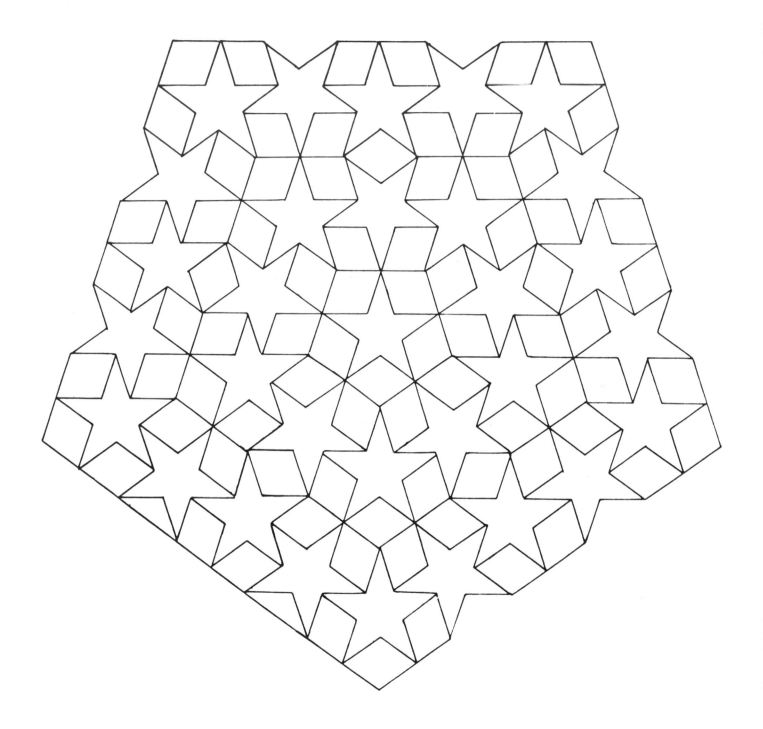

Plate 16

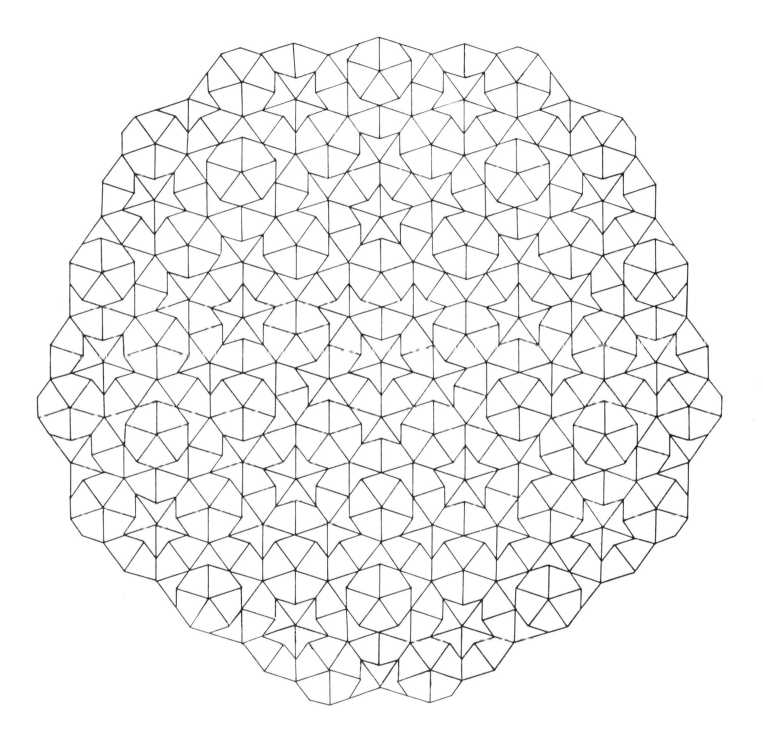

Plate 17

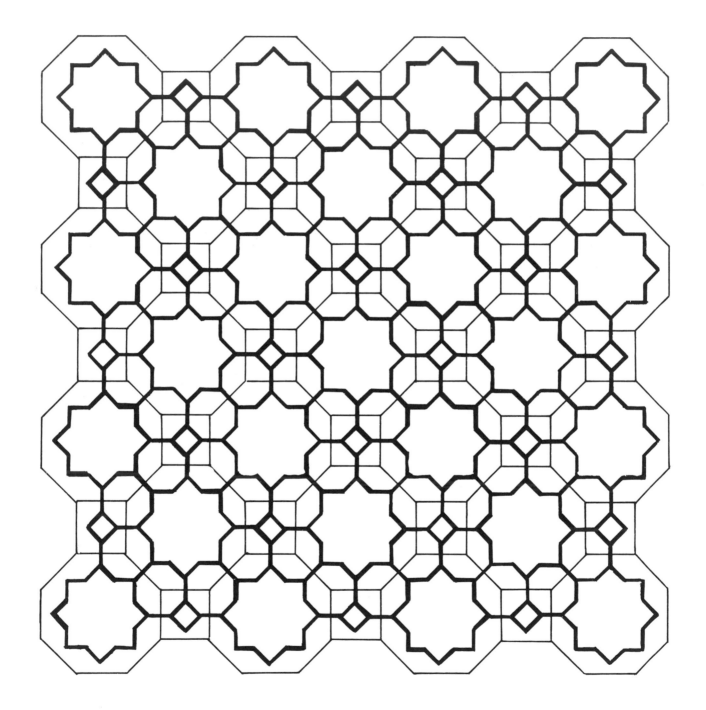

Plate 18

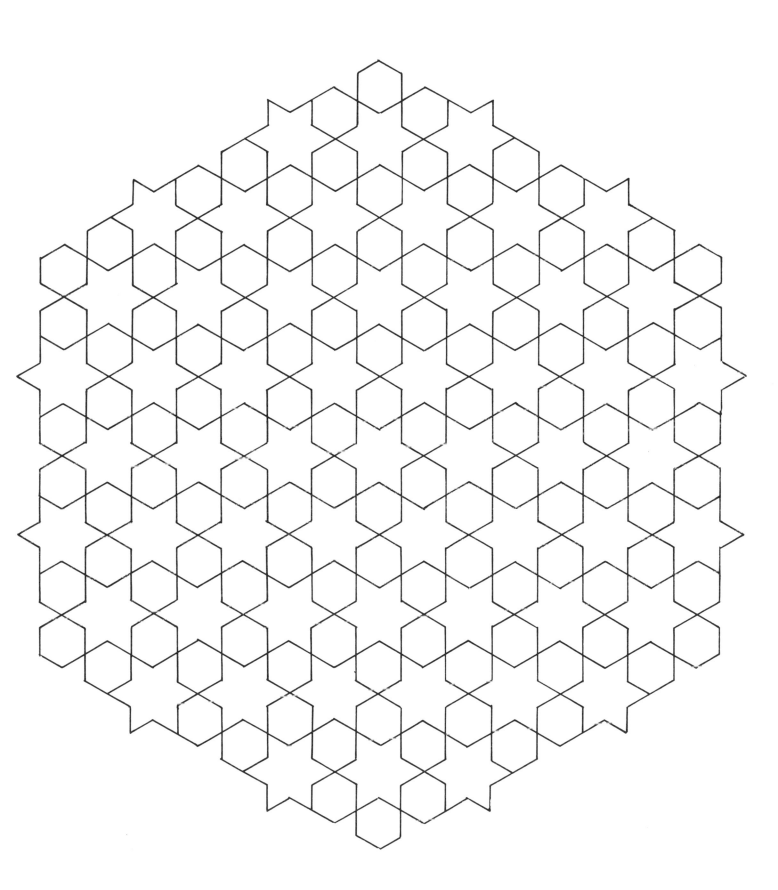

Plate 19

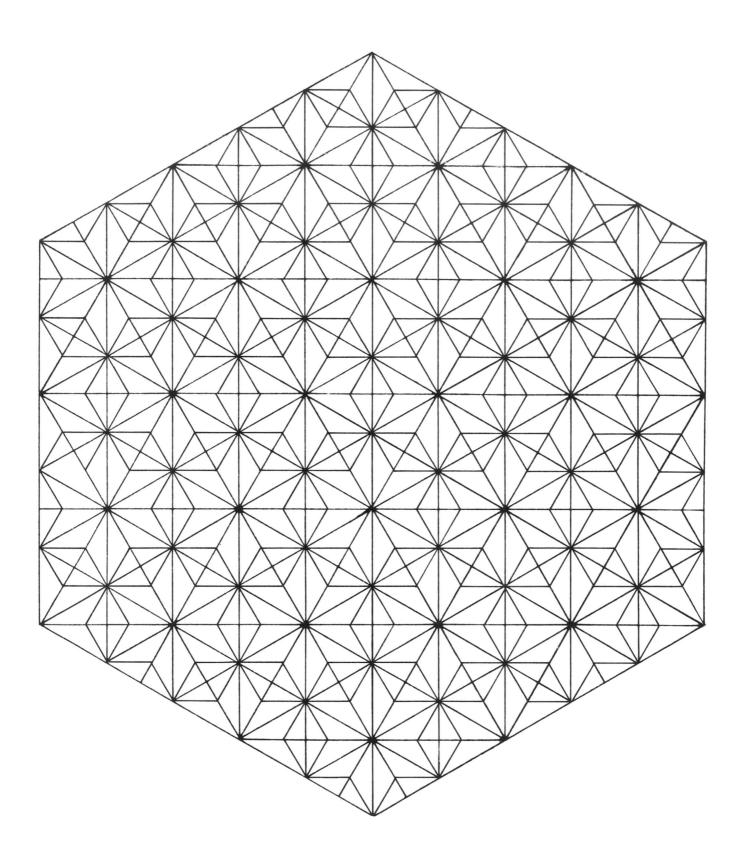

Plate 20

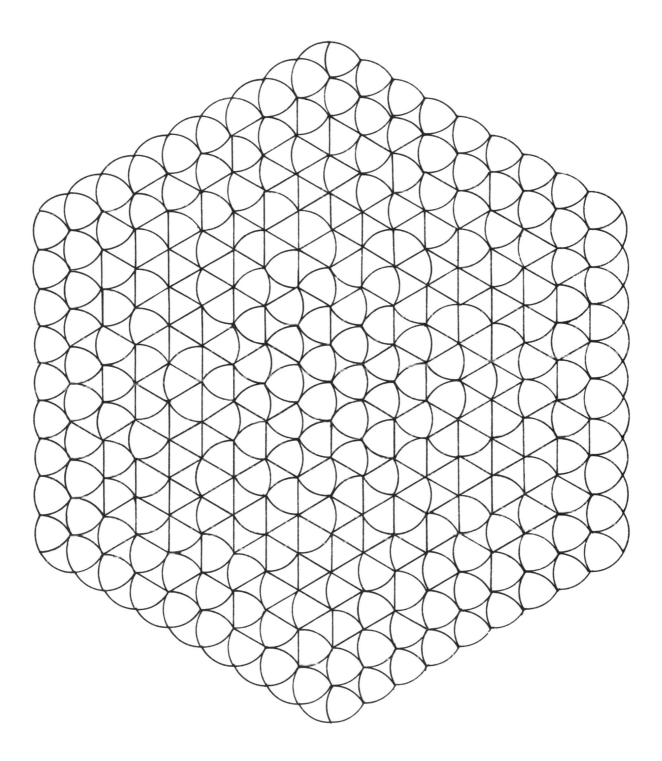

Plate 21

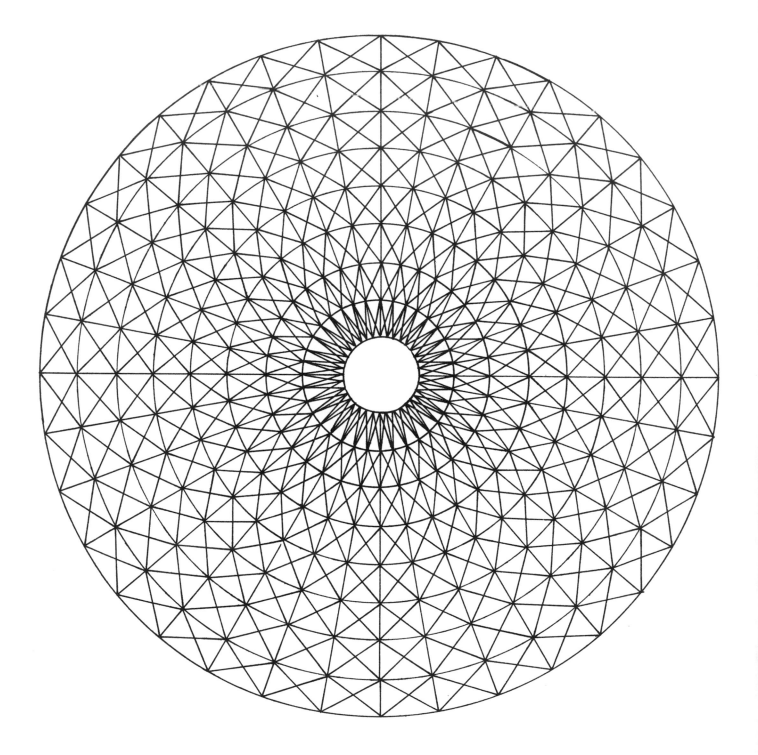

Plate 22

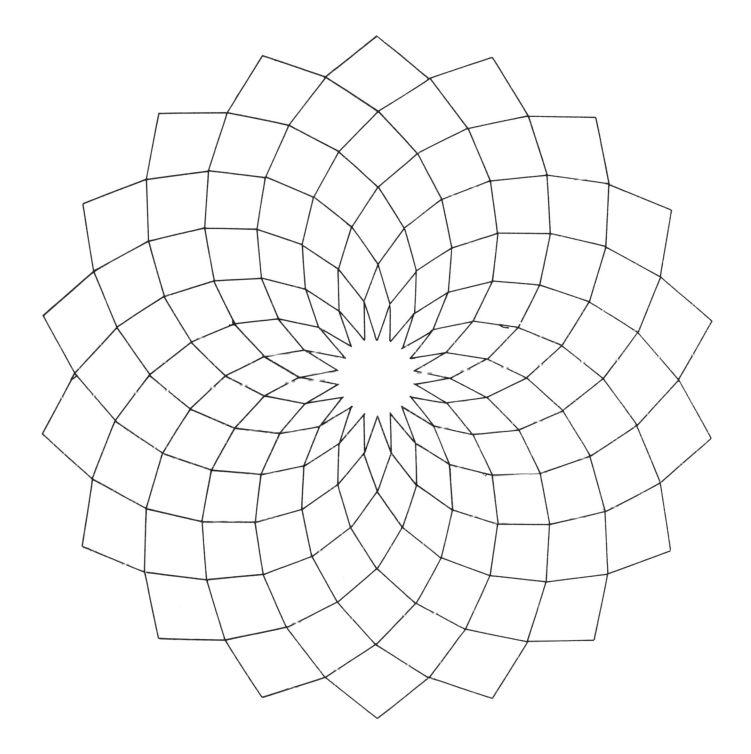

Plate 23

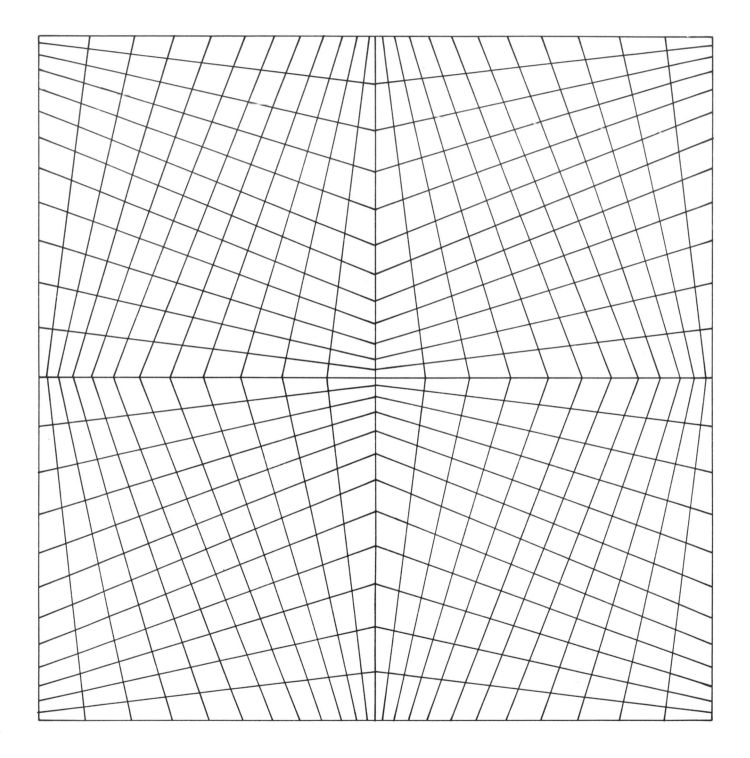

Plate 24

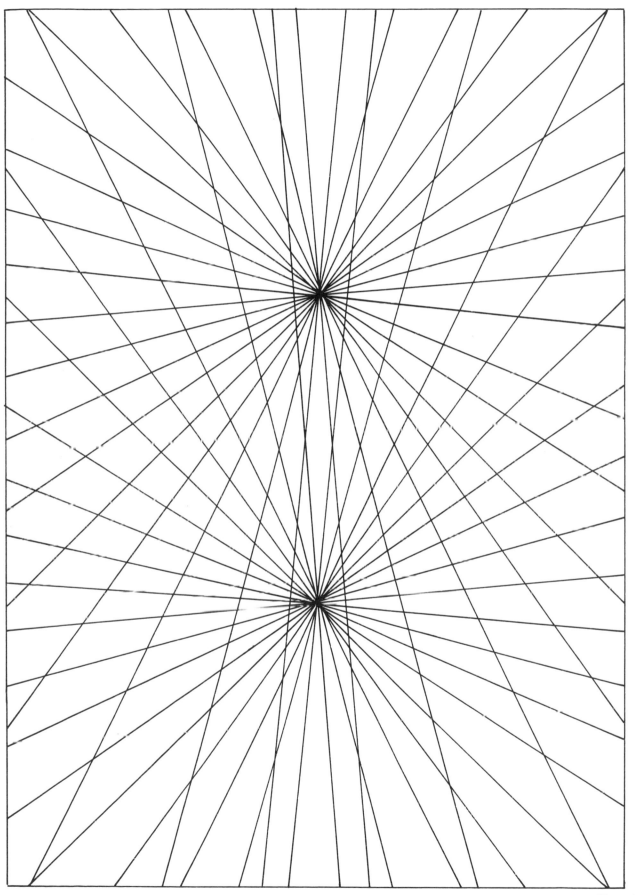

Plate 25

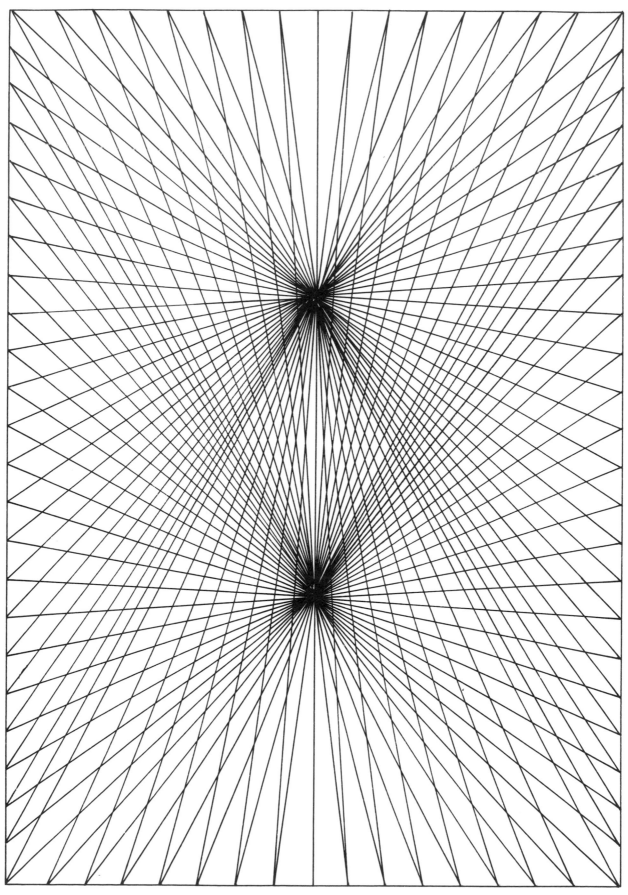

Plate 26

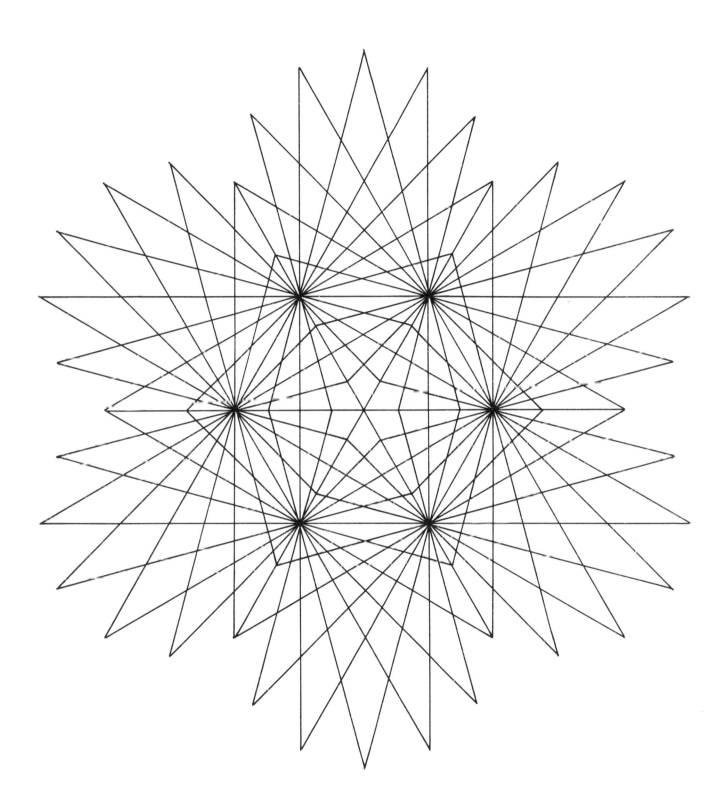

Plate 27

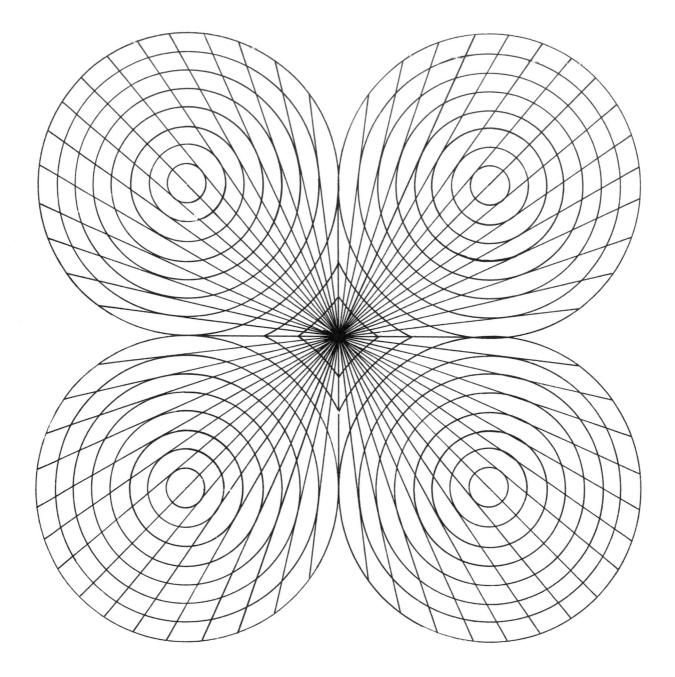

Plate 28

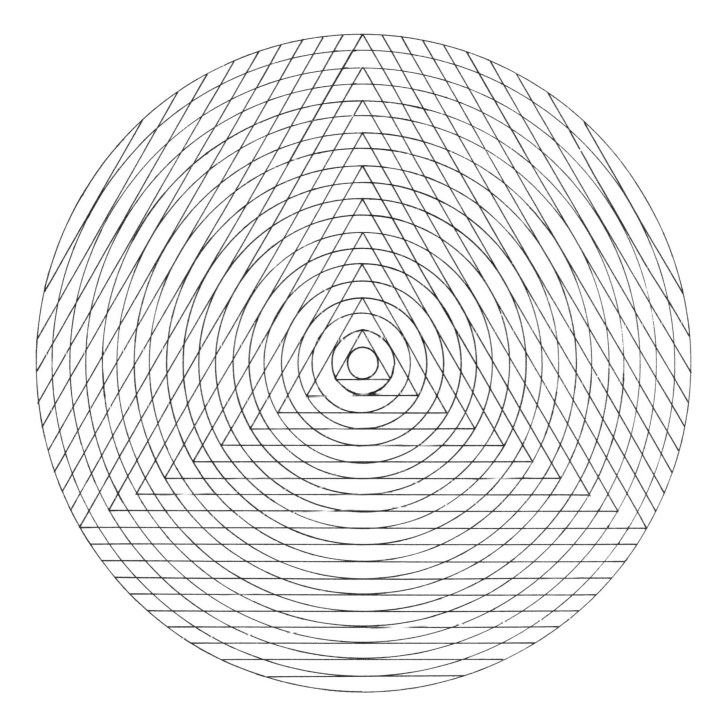

Plate 29

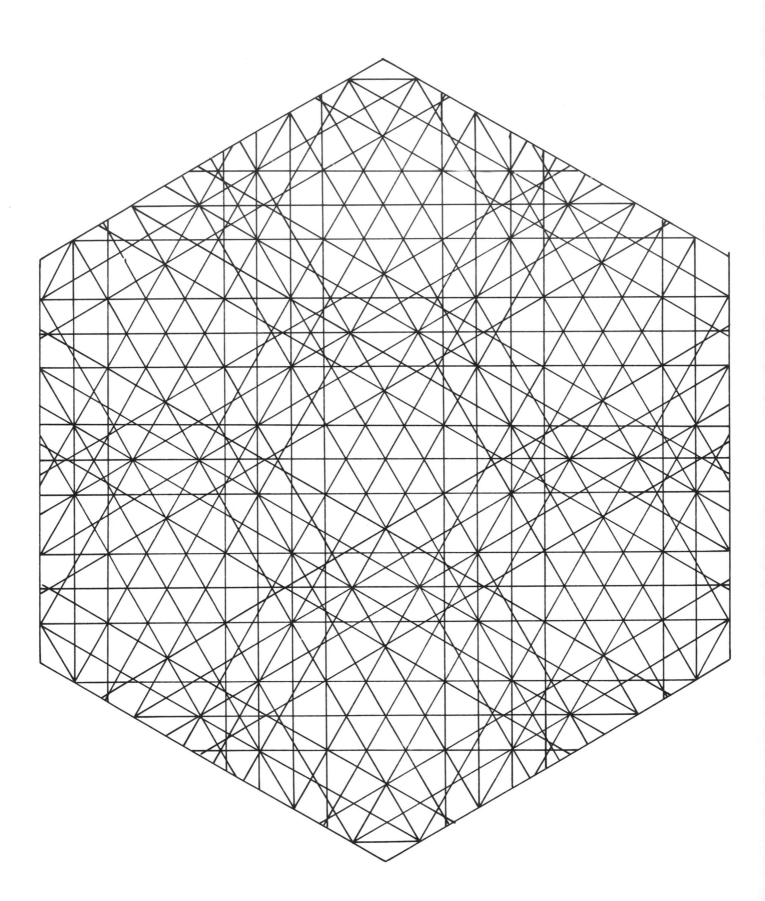

Plate 30

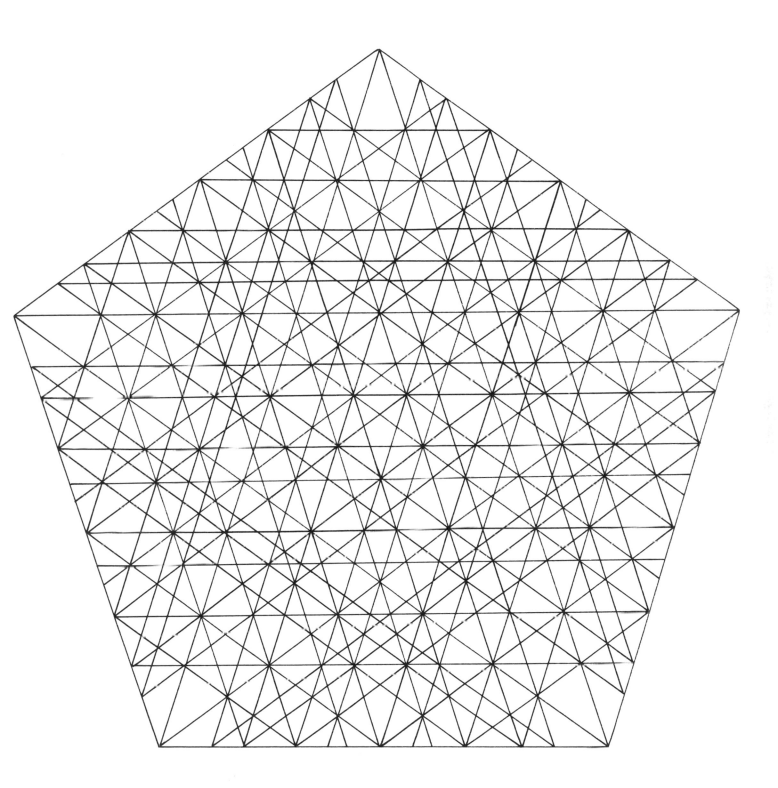

Plate 31

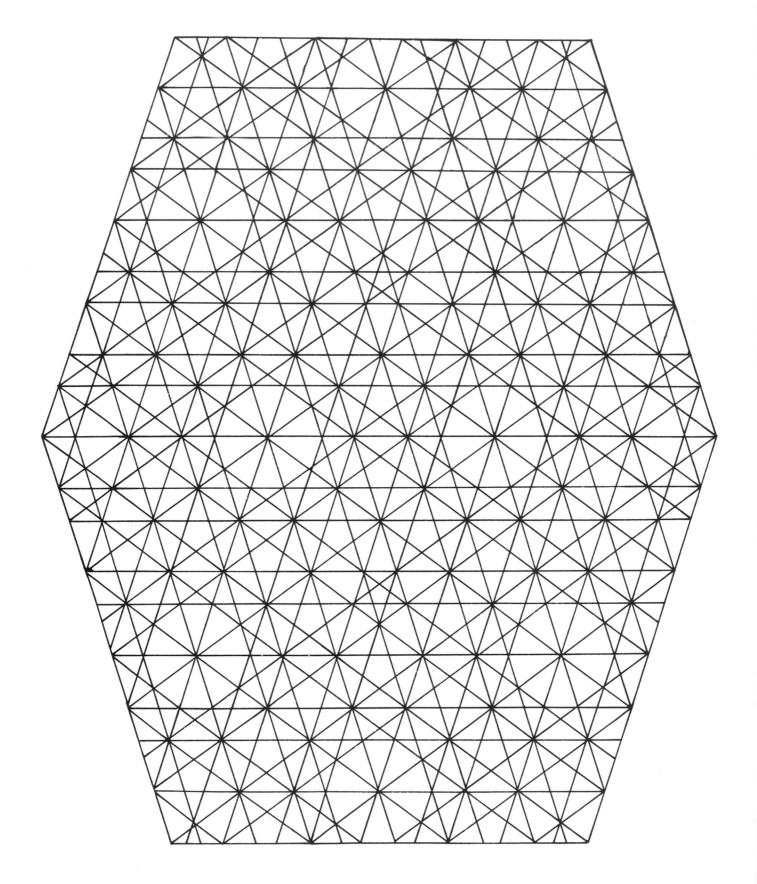

Plate 32

By using various combinations of these nine processes, an infinite number of symmetrical or periodic patterns can be developed from simple tessellations (e.g., Plates 1–21). Many of these can be developed further by combination of small shapes or infilling of large areas. These methods can also be used to produce tessellating monograms. For example:

Fig. 98

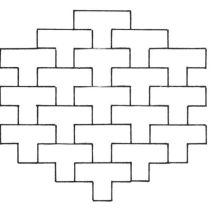

Fig. 99

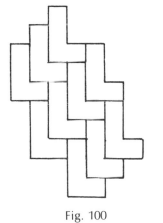

Fig. 100

Fig. 101

Fig. 102

Fig. 103

Fig. 104

15

Fig. 105

Most patterns considered so far have been built up by fitting several small units together until a surface is completely covered. In the following pages the designs are constructed from small units which are a consequence of dividing the plane of paper into many parts by sets of lines.

A pattern of squares (105) is simply the result of overlapping a series of vertical lines with a series of horizontal lines. If one set of lines is moved to a different orientation we obtain a tessellation of diamonds (106). When three series of parallel lines are superimposed we obtain triangles whose shape depends on the relative orientations of the sets of lines (107, 108).

In this type of tessellation formed by superimposition of grid lines, the number of lines meeting at each intersection is always an even number, and so all such patterns require only two colors for effective shading.

On pages 2 and 3, above, it was shown that the chessboard pattern formed by a tessellation of squares takes on different appearances when the spacing of the lines is varied. In Figure 6 the spacings change steadily, and in Figure 10 they fluctuate, i.e., are alternately wide and narrow. Another possible variation is to move either one or both sets of lines so that they are no longer parallel (109). These tessellations may be developed further by division of each tessera and then recombination.

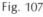
Fig. 106

Fig. 107

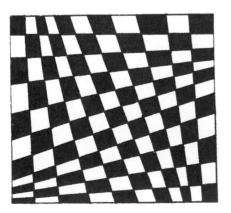
Fig. 108

Fig. 109

In addition to changing the spacing and orientation of lines in a square pattern, we can also alter the lines themselves. If all straight lines are replaced by wavy lines passing through points of intersection, then three more variations are produced.

(1) If each set of horizontal lines is in phase with each other and each set of verticals is in phase, as in

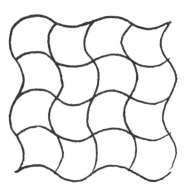

Fig. 114

Fig. 110	Fig. 111

and

then we produce the pattern in Figure 114.

(2) If both sets of lines are out of phase with adjacent lines, as in

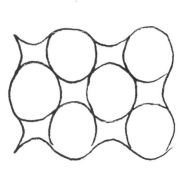

Fig. 115

Fig. 112	Fig. 113

and

then we produce either a single tessellation as in Figure 115 or a double tessellation as in Figure 116.

(3) If one set of lines is in phase and the other out of phase the resulting design is as in Figure 117.

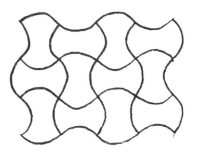

Fig. 116

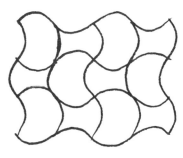

Fig. 117

17

If the straight grid lines are replaced by serpentine lines of half the wavelength of those on the previous page, then other shapes are created. When both sets of lines are out of phase the only possibility is as in Figure 118, but when both sets are in phase the result is as in Figure 119 or 120. If one set is in phase and the other is out of phase, then Figure 121 is produced.

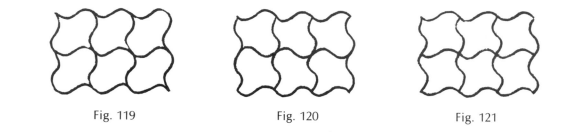

Fig. 118 Fig. 119 Fig. 120 Fig. 121

Combination of adjacent areas in these designs results in the following shapes (122–127), each of which can be used to produce a single tessellation. The processes of division, recombination and modification can also be applied to create many other patterns, each of which can be shaded in just two colors to produce interesting effects.

Fig. 122 Fig. 123 Fig. 124 Fig. 125 Fig. 126 Fig. 127

Having considered numerous variations on the theme of squares, we can turn to other themes based on overlapping grids. Consider the simple pattern formed when a grid of concentric circles of steadily increasing diameter overlaps a grid of lines radiating from the center, like spokes of a wheel, at regular intervals (128). When viewed at an angle or with partially closed eyes this gives the impression of numerous flower-petal shapes arranged about the center. Other impressions are created by a multitude of variations on this simple theme. For example:

(1) Leaving the spokes at fixed intervals, let the increase in the size of successive circles change such that the amount of increase itself
 (a) increases uniformly (129)
 (b) decreases uniformly (130)
 (c) fluctuates rapidly (131).

(2) Allowing the circles to increase steadily in size, as in Figure 128, let the intervals between the spokes
 (a) change slowly (132)
 (b) alternate between large and small intervals.

These variations can be used together to produce six more types of design, as, for example, in Figures 133, 134 and 135.

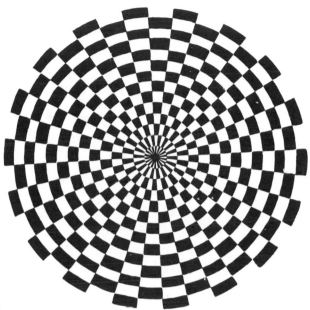

Fig. 128

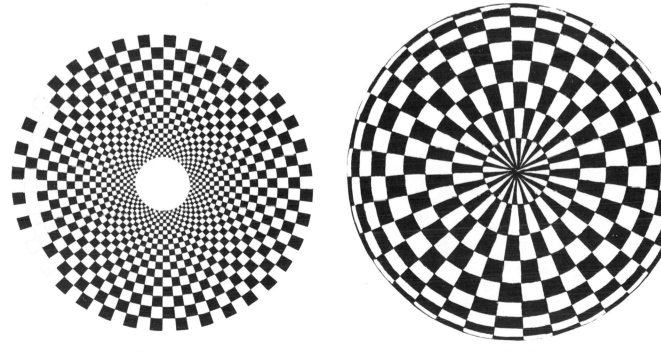

Fig. 129

Fig. 130

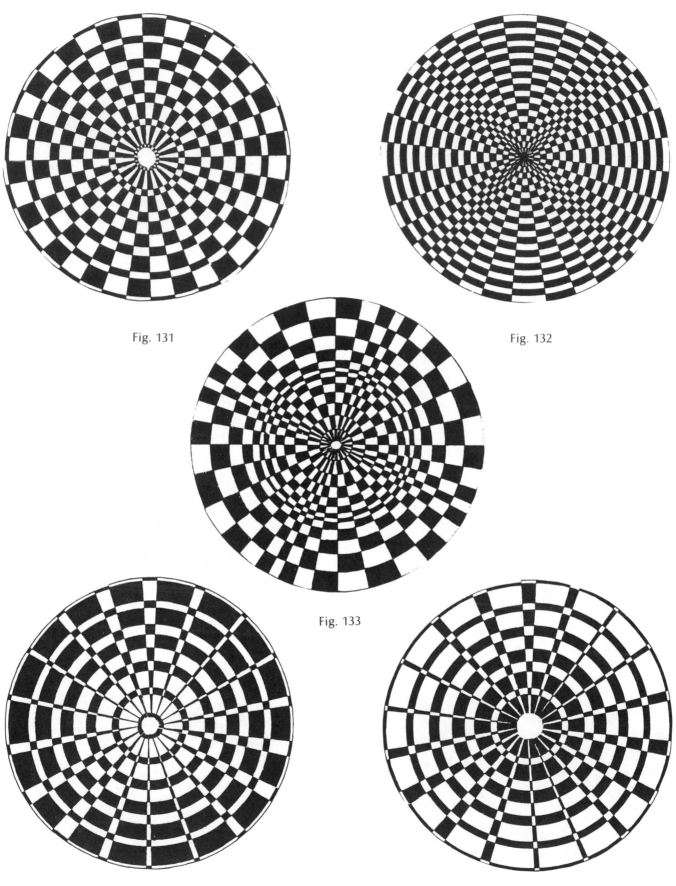

Fig. 131

Fig. 132

Fig. 133

Fig. 134

Fig. 135

In all of the variations discussed so far, straight lines have radiated from the center of a circle, but other variations can be produced by replacing these straight lines by

- **(a)** semicircles (136)
- **(b)** serpentine lines of constant wavelength, either in phase or out of phase
- **(c)** serpentine lines whose wavelength steadily changes (137).

Similarly the concentric circles can be replaced by crenulated circles (138) or by concentric polygons (139). Another variation is to move the center of the radiating spokes away from the center of the circles, the spokes then being drawn as tangents rather than at equal intervals (140). Further development can also be achieved by steadily moving the centers of the circles so that they are no longer concentric (141).

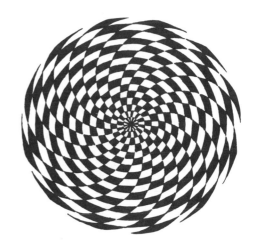

Fig. 136

Fig. 138

Fig. 139

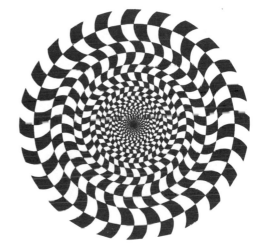

Fig. 137

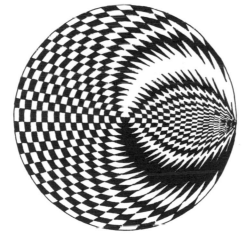

Fig. 140

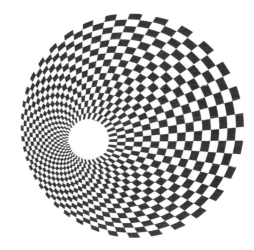

Fig. 141

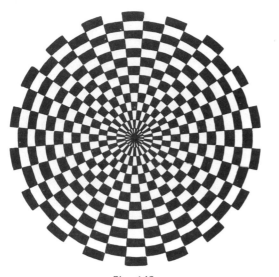

Fig. 142

If we return to the basic simple tessellation (142) we can apply a different type of variation, viz., division and recombination.

(1) the tiles can be divided diagonally in two, and the resulting pattern shaded in two different ways (143, 144)

(2) the tiles can be divided in two in alternate directions around each circle (145)

(3) this division can also alternate in direction along each radius (146)

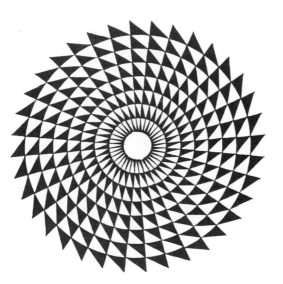

Fig. 143

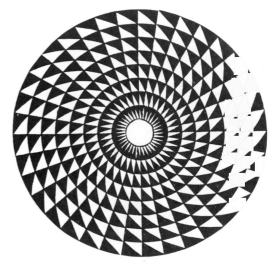

Fig. 144

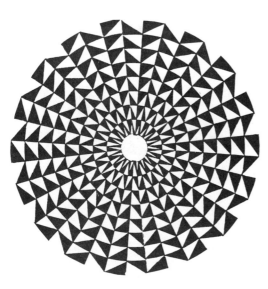

Fig. 145

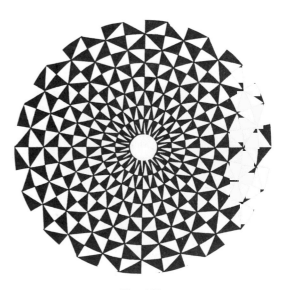

Fig. 146

(4) the triangles in Figures 144–146 can be recombined in pairs in a variety of ways to produce the larger triangles in Figures 147–151 (some of these patterns can be shaded in two different ways; e.g., compare Figures 150 and 151)

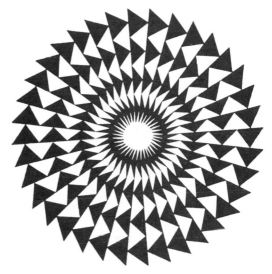

Fig. 147

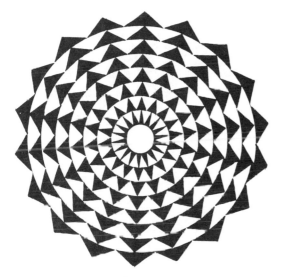

Fig. 148

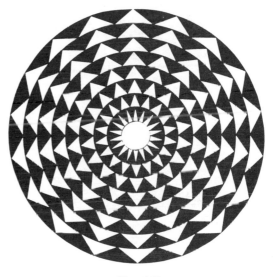

Fig. 149

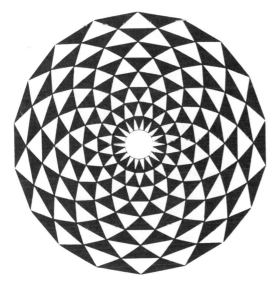

Fig. 150

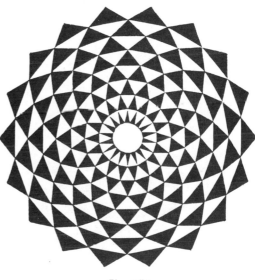

Fig. 151

(5) the triangles in Figures 144–146 can be combined in pairs to form the pseudo-parallelograms in Figures 152–154

(6) sets of four triangles in Figure 146 can be combined to give the kite-shaped tiles in Figure 155

(7) pairs of parallelograms produce chevrons in a variety of arrangements (156–160).

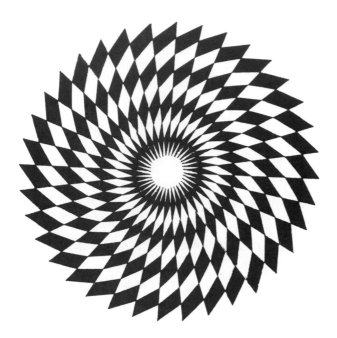

Fig. 152

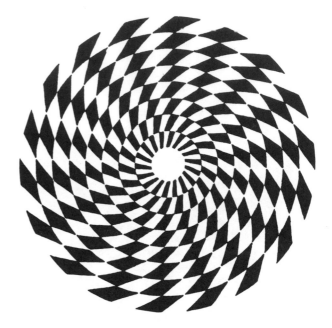

Fig. 153

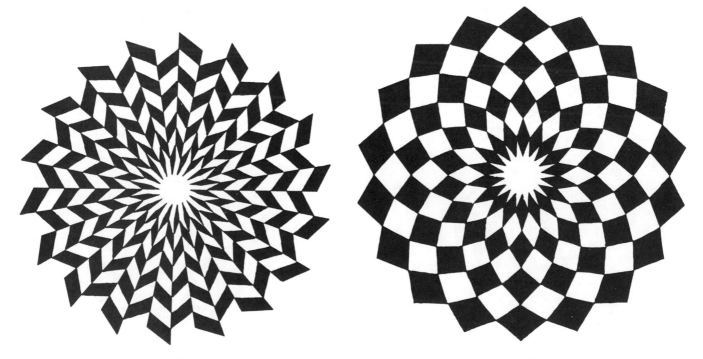

Fig. 154

Fig. 155

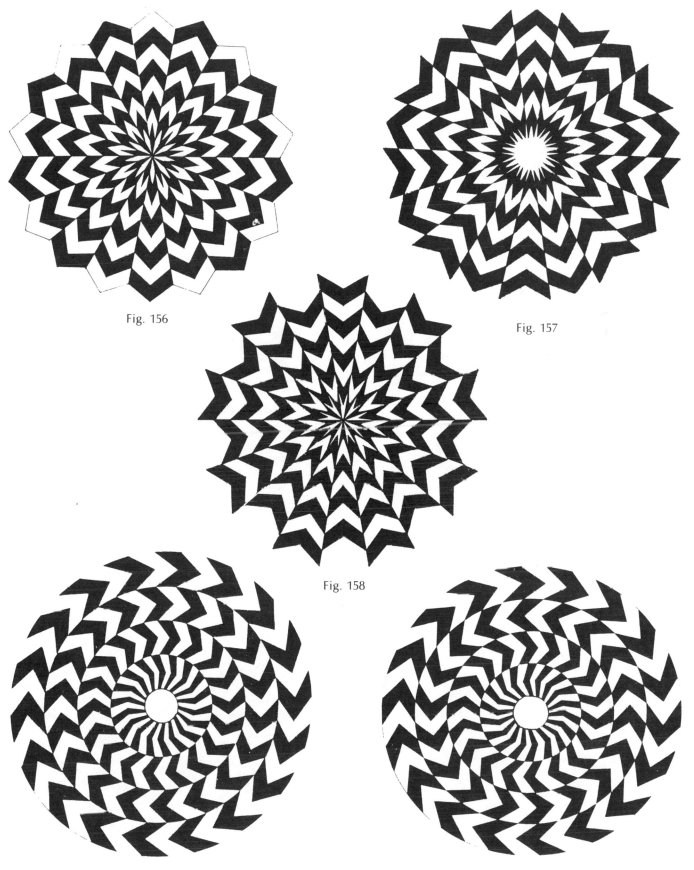

Fig. 156

Fig. 157

Fig. 158

Fig. 159

Fig. 160

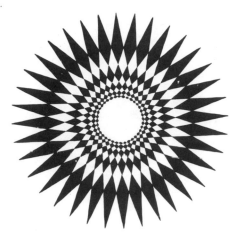

Fig. 161

The prolific nature of this theme of circles and spokes suggests that other basic grids may be just as versatile. The patterns on this page are based on the following grids:

(a) overlapping chords of a circle (161)
(b) parallel lines and concentric circles (162)
(c) parallel lines and radiating lines (163)
(d) two sets of concentric circles (164)
(e) two sets of radiating lines (165).

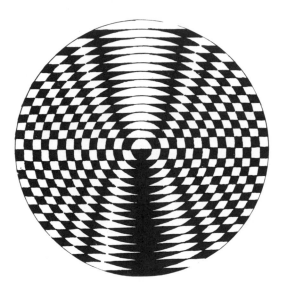

Fig. 162

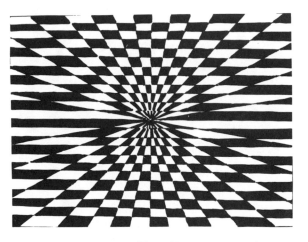

Fig. 163

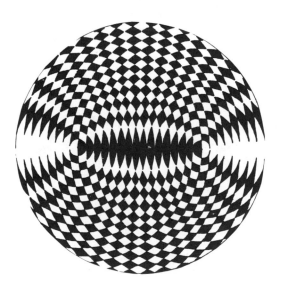

Fig. 164

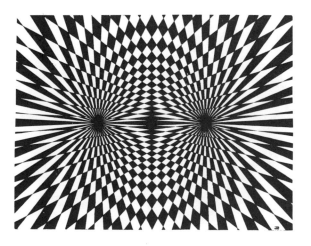

Fig. 165

Other grids which form tessellations are found in the construction of complex mathematical curves (166–170).

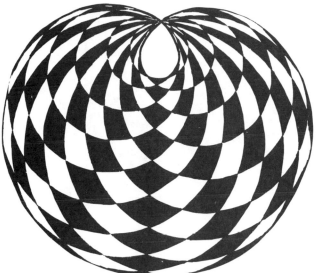

Fig. 168

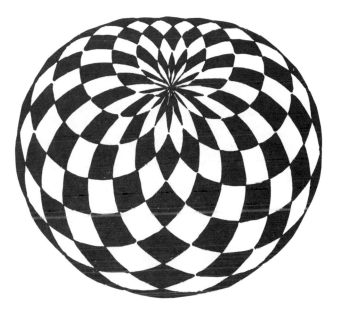

Fig. 166

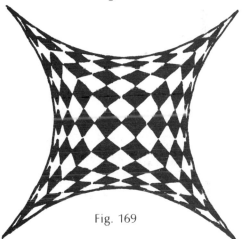

Fig. 169

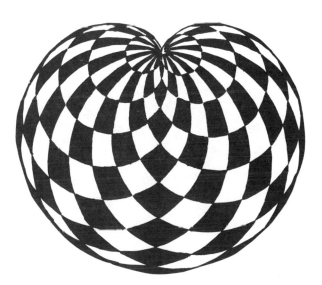

Fig. 167

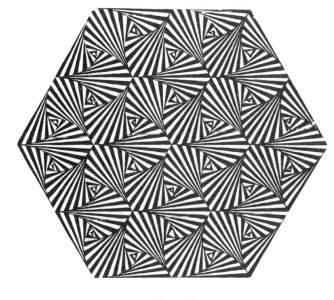

Fig. 170

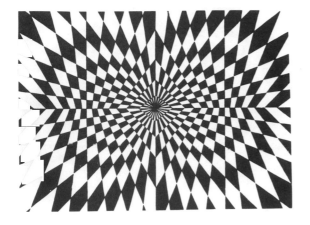

Fig. 171

Most of these designs can be described only as artistic exercises in graphics rather than as Op Art, for they involve little freedom of expression or aesthetic creativity. By using the patterns imaginatively, however, you can create pictures with eye-catching effects. The grids used in Figures 171–175 are similar to those already discussed; in most cases sections of simple patterns have been used repeatedly.

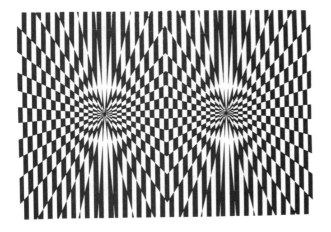

Fig. 172

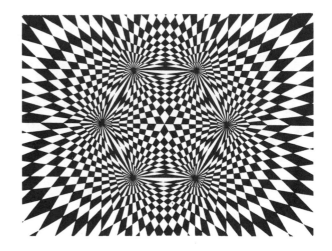

Fig. 173

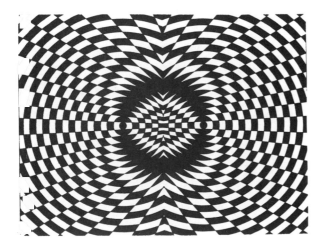

Fig. 174

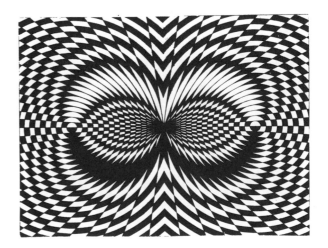

Fig. 175

Finally, it should be noted that tessellations can be used in art work which is neither optical nor regularly geometrical. In the examples in Figures 176–179, a feeling for balance and form has been used to create pictures which have their roots in the tesserae of Roman times.

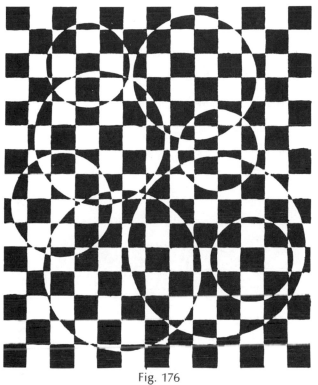

Fig. 176

Fig. 177

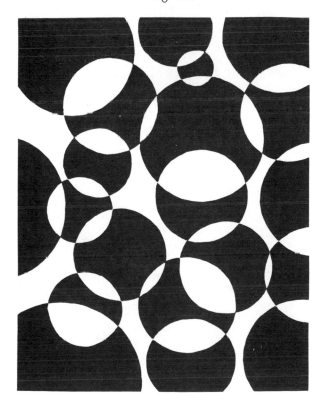

Fig. 178

Fig. 179

DESCRIPTIVE LIST OF PLATES

1. A single tessellation which is the reciprocal of the semiregular pattern (Figure 35). It has a sixfold center of rotational symmetry but no lines of mirror symmetry.

2. A semiregular pattern with two lines of mirror symmetry. It is formed by overlap of lozenge-shaped decagons.

3. A single tessellation which is the reciprocal of Plate 2. It can be viewed as a grid of large distorted hexagons superimposed on an identical grid.

4. A semiregular pattern formed by overlap of dodecagons or expansion of a regular hexagon grid.

5. A double tessellation formed by infilling the hexagons in Plate 4.

6. A triple tessellation formed by one method of infilling the semiregular pattern of dodecagons and triangles in Figure 22.

7. A double tessellation formed by infilling the hexagons in Plate 6.

8. A triple tessellation, related to Plate 6, formed by the alternative method of infilling the semiregular pattern of dodecagons and triangles in Figure 22.

9. A double tessellation formed by infilling the hexagons in Plate 8.

10. A semiregular pattern formed by expansion of the tessellation of dodecagons and triangles in Figure 22.

11. A triple tessellation formed by one method of infilling the dodecagons in Plate 10. The alternative method forms the semiregular pattern in Plate 4.

12. A double tessellation formed by infilling the hexagons in Plate 11.

13. A periodic pattern of decagons, pentagons and distorted hexagons based on the arrangement of ten pentagons surrounding one decagon. At every intersection the angles are 108°, 108° and 144°.

14. A periodic pattern of pentagons and diamonds; the angles involved are 36°, 108° and 144°.

15. A nonperiodic arrangement of pentagons and diamonds which has a fivefold center of rotational symmetry and five lines of mirror symmetry.

16. A nonperiodic pattern of stars and diamonds based on Plate 15; the angles involved are all multiples of 36°.

17. A nonperiodic pattern related to Plate 16; the angles involved are all multiples of 36°.

18. A periodic tessellation of squares, octagons and eight-pointed stars superimposed on a semiregular grid of octagons and squares.

19. A double tessellation in which no tiles of the same shape share a common edge. It can be viewed as tiles of one shape surrounding holes of the other shape. The shading determines which shape forms the holes.

20. A periodic tessellation based on two triangular grids superimposed on a pattern of overlapping hexagons.

21. A nonperiodic design with a threefold center of rotational symmetry. The eight different shapes are formed by applying a single modification process to some of the lines of a triangular grid.

22. A grid created by adding diagonals to the shapes formed when concentric circles and radiating lines overlap. This is the basis of all the designs in Figures 128 to 160.

23. A grid formed by combination of eight adjacent areas in Plate 22.

24. A deformed square grid in which the intervals along the edges and main axes follow an arithmetic progression.

25. Grid related to Figure 8, formed by two sets of straight lines which radiate at 10° intervals. The slight curving appearance is an illusion.

26. Grid formed by two sets of lines which radiate to points equally spaced around the perimeter.

27. Grid formed by six sets of lines which radiate at 15° intervals from the corners of a hexagon.

28. Grid formed by four sets of steadily increasing concentric circles and a set of radiating lines which are drawn as tangents to these circles.

29. Grid formed by a set of concentric triangles and their inscribing and circumscribing circles.

30. Grid formed from six sets of parallel lines oriented at 30° intervals.

31. Grid formed by extending all the sides of the shapes in Plate 15. It consists of five sets of parallel lines oriented at 36° intervals; the spacings between the lines are related to the golden ratio 1:1.618.

32. A more complex grid formed by further development of part of Plate 31.